Centre Business,
&T(

C28607

WHY PEOPLE PHOTOGRAPH

WHY
PEOPLE
PHOTOGRAPH

SELECTED ESSAYS
AND REVIEWS

by
ROBERT ADAMS

APERTURE

Library of Congress Catalog Card Number: 94-76843
Hardcover ISBN: 0-89381-597-7
Paperback ISBN: 0-89381-603-5

Book and jacket design by Wendy Byrne
Composition by Jenny Ma-Tay Isaacs
Printed and bound in the United States by RR Donnelly & Sons Company

The Staff at Aperture for *Why People Photograph* is:
Michael E. Hoffman, Executive Director/Editor in Chief;
Roger Straus III, Publisher/General Manager; Lynne Honickman, Editor;
Michael L. Sand, Managing Editor; Stevan A. Baron, Production Director;
Sandra Greve, Production Manager; Katie Kirtland, Editorial Assistant;
Eugenia Leftwich, Copy Editor; Meghan McCarthy, Editorial Work-Scholar

Aperture Foundation, a not-for-profit organization, publishes *Aperture* magazine, books, and
limited-edition prints of fine photography and presents photographic exhibitions
worldwide. A complete catalog is available on request.

Aperture Foundation,
including Book Center and Burden Gallery:
20 East 23rd Street, New York, New York 10010.
Phone: (212) 505-5555, ext. 300. Fax: (212) 979-7759.
E-mail: info@aperture.org

Visit Aperture's website: www.aperture.org

To subscribe to *Aperture* magazine write Aperture, P.O. Box 3000, Denville, New Jersey 07834,
or call toll-free: (866) 457-4603. One year: $40.00. Two years: $66.00. International
subscriptions: (973) 627-2427. Add $20.00 per year.

First Edition
10 9 8 7 6 5

To Barry Lopez

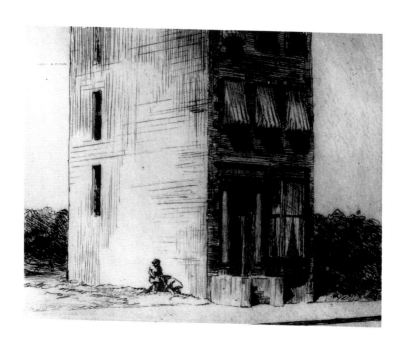

I Edward Hopper, *The Lonely House*, 1922

FOREWORD

Though these essays were written for a variety of occasions, they have a recurring subject—the effort we all make, photographers and nonphotographers, to affirm life without lying about it. And then to behave in accord with our vision.

Some of the facts that we encounter are recorded perfectly in an etching by Edward Hopper (photographers live by all kinds of pictures), one that shows a new house isolated against a line of brush. The side of the building makes unmistakable a crowding to follow, and at the front we see part of the cost: Large draperies and awnings indicate that our enjoyment of the view is weakening.

Jean-Luc Godard said, in one of his films about modernity, that now "the future is more present than the present." Each of us has experienced that, but Hopper's picture reminds us of an additional truth: There is still time—in the lee, in the quiet, in the extraordinary light.

WHAT CAN HELP

COLLEAGUES

YOUR OWN photography is never enough. Every photographer who has lasted has depended on other people's pictures too—photographs that may be public or private, serious or funny, but that carry with them a reminder of community.

Nicholas Nixon made one that I especially treasure of our Airedale (plate II). It is a perfect record of her intense gaze, and was included in a show at the Museum of Modern Art in New York, although I prize it as much for the recollection it affords of first meeting the photographer. The dog had barged ahead at our front door, and when Nick saw her through the screen his delight was so undisguised that Kerstin and I and then he started laughing; in the confusion he gave up on words, but managed to find in his billfold a snapshot of himself as a child with an Airedale. All of which—the dog, Nick's enjoyment of the moment, his sense of humor, his gift as a photographer—returns to me now as I look at the picture that he eventually made that day.

I rely on the photograph just as I do on those of others' enthusiasms—baseball, cottonwoods, children, grain elevators, basalt, petroglyphs, the wonders of Peru, Japan, Greece, India. . . . And though the photographers' fondness for

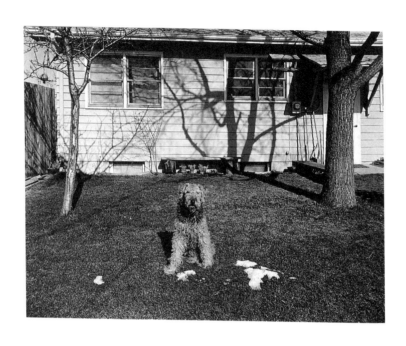

11 Nicholas Nixon, *Fred*, 1975

these subjects is evident in their pictures, I am especially strengthened by those where I can also recall it in their letters and conversation.

If I like many photographers, and I do, I account for this by noting a quality they share—animation. They may or may not make a living by photography, but they are alive by it.

I think for example of a friend who, when he was a young man, sometimes took pictures along country roads while sitting half up out of the sun roof of his moving car, steering with his feet. You couldn't argue him out of this practice because the rationale was to him so clear—the view. And apparently he was meant to do it, because over the years he went on to assemble a vast photographic celebration of Colorado life. When I hear his voice on the phone now, full of avidity even in old age, I promise myself that I will take grand, unsafe pictures.

I remember too an acquaintance who, when he was asked by a dealer to autograph a book, wrote his name and then, burning his bridges, "NOT FOR RESALE." It was a reckless thing to do, but also a kind of life insurance. Many photographers in fact remind me in temperament of Thomas Hart Benton; in addition to painting, he said, what he liked was to "drink whiskey and talk big."

Why is photography, like the other arts, that kind of intoxication? And a quieter pleasure too, so that occasionally photographers discover tears in their eyes for the joy of seeing. I think it is because they've known a miracle. They've been given what they did not earn, and as is the way with unexpected gifts, the surprise carries an emotional blessing. When photographers get beyond copying the achievements of others, or just repeating their own accidental first successes, they learn that they do not know where in the world they will find pictures. Nobody does. Each photograph that works is a revelation to its supposed creator. Yes, photographers

do position themselves to take advantage of good fortune, sensing for instance when to stop the car and walk, but this is only the beginning. As William Stafford wrote, calculation gets you just so far—"Smart is okay, but lucky is better." Days of searching can go by without any need to reload film holders, and then abruptly, sometimes back in their own yards, photographers use up every sheet.

I have to admit that there is another reason I like photographers—they don't tempt me to envy. The profession is short on dignity: Nearly everyone has fallen down, been the target of condescension (the stereotypical image of a photographer being that of a mildly contemptible, self-indulgent dilettante), been harassed by security guards, and dropped expensive equipment. Almost all photographers have incurred large expenses in the pursuit of tiny audiences, finding that the wonder they'd hoped to share is something few want to receive. Nothing is so clarifying, for instance, as to stand through the opening of an exhibition to which only officials have come.

Experiences like that do encourage defiance, however. Why quit while you're losing? And so there's room for idealism. There was no fortune or reputation to be made, for example, when Alex Harris arranged to publish a book of views by an elderly, obscure photographer in Chiapas, Mexico (*Gertrude Blom: Bearing Witness*, University of North Carolina Press, 1984). The only conceivable rationale was to share an understanding of a subject—contemporary Mayans—that both he and she believed was important. Similar motives have brought photographers Richard Benson and David Wing to help along others' efforts (see, for instance, Benson's *The Face of Lincoln*, published by Viking Press in 1979, a book that reproduces all the known portraits of Lincoln, and look up *Eugene Buechel, S.J.: Rosebud and Pine Ridge Photographs, 1922-1942*, published by Grossmont College in 1974, a volume that was

assembled by Wing and a group of his students to make available remarkable views of Lakota reservation life). In the company of photographers like Harris, Benson, and Wing we discover a galvanizing sense of purpose.

I respect many photographers for their courage. Sometimes this quality is undramatic and private—the grit to fight bad odds with discipline. "I feel like I have been living in a small hole somewhere," one writes in good-humored self-mockery, "ever busy with problems of nest management." An aspect of that is likely to be, of course, the threat of insolvency, something with which the unlucky have to learn to live as they would with a chronic disease. One photographer I admire, for instance, had to go back to cleaning houses when her Guggenheim fellowship ran out.

There can be physical danger as well. Two acquaintances have while working been injured by livestock, and one when he fell from a railroad car. Several are making pictures at hazardous waste sites, and another has been recording the no-man's-land beneath Los Angeles freeways.

Photographers must also withstand, with the help of their families and friends, the psychic battering that comes from what they see. In order to make pictures that no one has made before, they have to be attentive and imaginative, qualities partly assigned and partly chosen, but in any case ones that leave them vulnerable. When Robert Frank put down his camera after photographing *The Americans* he could not so readily escape the sadness of the world he recorded as could we when we closed the book.

Paradoxically, photographers must also face the threat that their vision may one day be denied them. Their capacity to find their way to art, which is their consolation—to see things whole—may fail for an hour or a month or forever because of fatigue or misjudgment or some shift in spirit that cannot be predicted or understood or even recognized

until it has happened past correction. For every Atget, Stieglitz, Weston, or Brandt who remain visionary to the end, there is an Ansel Adams who, after a period of extraordinary creativity, lapses into formula.

A bravery I respect in many photographers, especially now, is their courage for orderly retreat, that hardest of tactical maneuvers—the intelligence to see probabilities, the nerve to wait until the last possible minute to give ground, and then the will to turn and hold again until the next uneven confrontation. Consider, for example, those photographers who once worked in Glen Canyon to try to mobilize public opinion against building a dam there, and who, after it was built, continued to photograph the Southwest. I saw Glen Canyon only briefly in its final days, before I became a photographer, but the glimpse I had of it suggested a place that was in some respects as remarkable as the Grand Canyon—more intense, even, for its intimacy. How commendable to have known this geography well enough to have made hundreds of pictures there—to have loved it that much—and then to go on working without it. And without illusions about human beings.

One additional quality that I admire in my colleagues is a basis for the others: their awareness of finalities and of our place in nature. Years ago I enjoyed a winter day with a friend who was taking pictures along the Washington coast; he wrote later of a cove that we had explored: "I think now of the blackened driftwood—of the air and light, of the sea, rocks, surf, and trees—it was a world largely complete—for a moment, in that good air, it was perfect."

Garry Winogrand's subject was, I now believe, also perfection, though many of his street scenes appear to tip under the weight of roiling confusion—so much so that for a long time I did not appreciate his accomplishment. I even wondered

if I would like him in person, though when I met him one afternoon at a conference in Carmel I certainly did, as anyone would have. He was cheerful, ardent, and without pretense.

After Winogrand died, a mutual acquaintance told me that he had said he wanted to make pictures related to mine. I could hardly believe it because our work seemed so far apart, but later when I saw views that he had recorded in Los Angeles I realized that we had in fact hoped to make some of the same discoveries.

Since then I have begun to suspect that aspects of my work might be changing, becoming a little more like his (the shift is puzzling to me, which I hope may excuse the presumption in speaking of it). If so, I welcome it, because he was accepting of complexity in ways that I admire.

The second time I talked with Garry Winogrand, and the last, was during an informal lunch at the Fraenkel Gallery in San Francisco. Photographers, curators, and teachers had seated themselves on the carpeted floor of the gallery's office, a room suffused with indirect natural light; conversation was animated as people shared their enthusiasm for pictures and enjoyed French bread and wine. Winogrand had to leave early to catch a plane, but before the party closed in over the space he'd occupied there was visible a humorously untidy ring of bread crumbs where he'd been. He had, as he did when he photographed, turned to everyone, taking pleasure in their company and in the good food. It makes me smile to think of him there in that halo made from the staff of life.

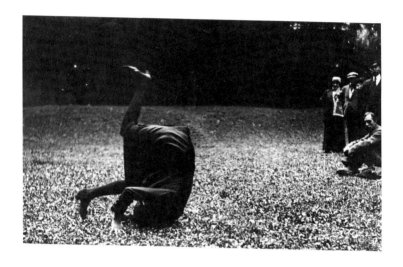

III Jacques-Henri Lartigue, *Simone Roussel in Saint-Cloud*, 1913

HUMOR

MARK TWAIN said that analyzing humor was like dissecting a frog—both die in the process. These days we want to try to let them both live.

Visual art that is funny has always been, however, a rare species. It is hard to think of a dozen European or American paintings that are as amusing as even a few paragraphs of *Huckleberry Finn*. There have been, it is true, lots of witty pictures—ones by Hogarth and Paul Klee and Edward Ruscha, for example—but not many of these have aimed to be more than wry. Certainly the emphasis in recent times has been on irony, with all that this implies of grimness.

Might we just nudge the frog a little? Gently, to enjoy its hop, its haiku.

There, for instance, is Lartigue's cousin Simone, somersaulting if not hopping. We love her. Solemnly dressed, with inadequate head and the vestige of a tail, we look at her as in a mirror.

As we do at Erich Solomon's streamlined terrier (plate IV). You and I were that way once, leaning out of the family car.

Of course sometimes the best pictures emphasize that we are not the same as other animals. Dorothea Lange's

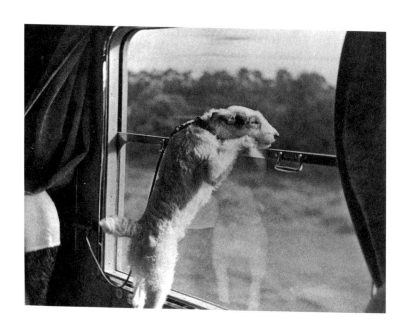

IV Erich Salomon, *Dog on Train Between Chicago and New York*, 1932

photograph of a man's dispute with a pig (plate V) makes this clear, enhanced as it is by Lange's affectionate record of the man's articulate fuming: "The pig—she took up and 'cided she warn't goin no fudder . . . Ah don't like dis yer pushin' and pullin'." We wouldn't either. Though we come to see a little of the pig's frustration too.

Occasionally people in funny pictures are wholly admirable, as is Buster Keaton under the Joshua tree (plate VI). What a canny stoic he is. We salute him: Life's a furnace, blazing hot; here's to Keaton, angled in his shady spot.

Many pictures aren't that good, however. They seem funny at first, but they don't stay that way, eventually making us sad or even bitter. Baudelaire spoke prophetically for many in the twentieth century when he said that he could "laugh but no longer smile." Our art has surveyed all the incriminating juxtapositions, all the plastic flamingos on the front lawn. Most of these pictures rehearse a formula that was run through long ago by the dadaists and surrealists, but we seem never to tire of it, apparently flattered at being addressed as people in the know. And distracted, so that we can forget the only question that matters—"Why care?"

Intentionally funny pictures that remain funny are unusual because they are hard to make, because the life that facilitates them is hard to live. Wit and good humor are both traceable to a sense of incongruity, but good humor requires more—acceptance. Richard Benson once joked that "funny pictures aren't quite serious," which is true except that they promote patience. I was myself improved a little, if I may brag, by such a photograph—Lee Friedlander's portrait of firemen lined up as in a graduation shot (plate VII). Without it my teaching career would have ended sooner.

Most photographs that stay funny have, I think, something in common: We can see in them that the subjects know they are part of a joke, and their awareness excuses us from

the discomfort that we might otherwise feel in smiling. The pictures are given to us by all parties, and so invite affection and identification rather than ridicule.

Perhaps this is why there are more funny pictures in family albums than in art books. At home we know each other, and can run back and forth to be subject and photographer, easy in each other's charity.

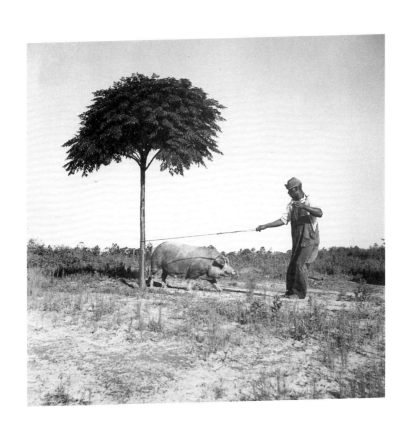

V Dorothea Lange, *By the Chinaberry Tree, near Tipton, Georgia*, 1938

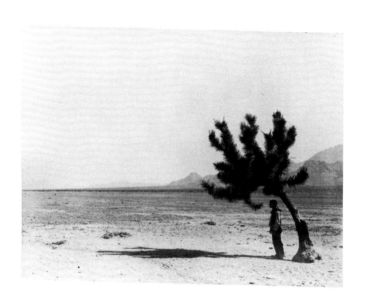

VI Photographer unknown, a publicity still for the movie *Go West*, 1925

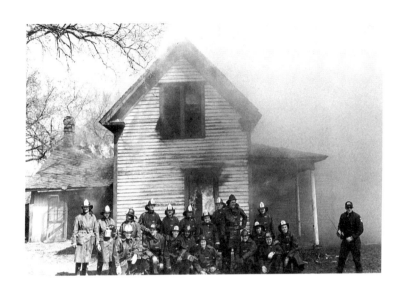

VII Lee Friedlander, *Minneapolis*, 1966

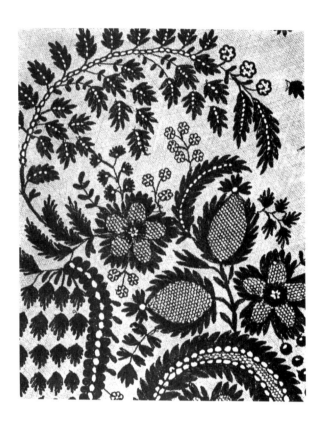

VIII William Henry Fox Talbot, *Lace Pattern*, ca. 1842

COLLECTORS

ARTISTS sometimes claim that they work without thought of an audience—that they make pictures just for themselves. We are not deceived. The only reward worth that much effort is a response, and if no one pays attention, or if the artist cannot live on hope, then he or she is lost.

Artists and collectors have occasionally ragged each other a little, with Daumier sketching connoisseurs as poseurs, and buyers sometimes calling artists children. But the truth is that collectors and artists are, in their strengths and weaknesses, much alike, and their squabbles, if any, are minor compared to their need of each other.

The most obvious characteristic they share is the nature and extent of their appetite. Whereas most people think of art as something inessential when compared, say, to food, collectors and artists have been known to try to make a meal of pictures. The abstract greenery in William Henry Fox Talbot's *Lace Pattern*, for example, could almost be, to

Most of these observations were included originally in "Photography and the Collector," in *Selections from the Strauss Photography Collection*, published by the Denver Art Museum in 1982.

hear them tell it, as nourishing as produce from the market.

Collectors share with artists a narrow but intense sensualism. The opportunity for this in photography might at first seem limited, but in fact an enjoyment of photographs is stronger for the subtle distinctions involved. Even tiny prints by Stieglitz can, despite being limited to black and white, make you a hedonist.

D. H. Lawrence, no stranger to matters of pleasure, observed that the profoundest of all sensualities is the sense of truth. Perhaps that explains another attribute shared by collectors and artists—self-confidence. None believes in democratic methods for judging art. None has ever held the slightest suspicion that a majority of people recognize the best art a majority of the time.

Collectors and artists respect this quality in each other. The painter John Constable lamented one timid potential buyer as "full of objections. A good undoer, but little of a doer." Artists admire collectors who are doers, people who, like themselves, are willing to take risks in an effort to build new syntheses. Samuel Johnson defined a collector as "he that collects scattered things together," suggesting the creative nature of the activity—assembling a new unity from what had before seemed disconnected and therefore without meaning. Just as the artist tries to bring varied aspects of life into a new harmony within one frame, so the collector often gathers and exhibits pictures together for the satisfaction of observing fresh relationships among different views and artists and even entire periods of art. The ultimate goal of both collector and artist is to make something whole and clear, something that will help us all. The motive for doing this, however, is initially personal: As the painter Robert Henri said, "In no work will you find the final word, nor will you find a receipt that will just fit you. The fun of living"—and of making pictures, and of collecting them—"is that we have to make ourselves."

WRITING

ART IS by nature self-explanatory. We call it art precisely because of its sufficiency. Its vivid detail and overall cohesion give it a clarity not ordinarily apparent in the rest of life. And so if the audience lives in the same time and culture as does the artist, and if the audience is familiar with the history of the medium, there is no need to append to art a preface or other secondary apparatus.

Successful writing about works of art is accordingly an unusual achievement. It is self-effacing, devoted to establishing the adequacy of the art without the writing. John Szarkowski described an appropriate measure for critical writing: "The better the writing is the more necessary it makes the picture." There are only a few commentators who can do that—Robert Hughes, for instance, and Szarkowski himself.

Several important artists have been effective critics—the painter Fairfield Porter was, for example, an accomplished writer for *The Nation*—but they have not earned reputations

Originally entitled "Why Can't Photographers Explain?," this essay was first published in *American Art*, Winter 1992.

either as artists or critics by explaining their own art. Photographers are quick to note this because they are so often asked to spell out the significance of their pictures, something they resist trying to do. Yes, they can say a little about what brought them to begin, though this is not to discuss what resulted, and they can describe the equipment they used and the processes they followed in the darkroom, but they know that if these are the secrets then the pictures are not very important.

The frequency with which photographers are called upon to talk about their pictures is possibly related to the apparent straightforwardness of their work. Photographers look like they just record what confronts them—as is. Shouldn't they be expected to compensate for this woodenness by telling us what escaped outside the frame and by explaining why they chose their subject? The assumption is wrong, of course, but an audience that knows better is small, certainly smaller than for painting. Photographers envy painters because they are usually allowed to get by with gnomic utterances or even silence, something permitted them perhaps because they seem to address their audience more subjectively, leaving it more certain about what the artist intended.

Years ago when I began to enjoy photographs I was struck by the fact that I did not have to read photographers' statements in order to love the pictures. Sometimes remarks about the profession by people like Stieglitz and Weston were inspiring, but almost nothing they said about specific pictures enriched my experience of those pictures. Photographers seemed so strikingly unable to write at length about what they had made, in fact, that I came to wonder if there was any exception at all, a single case where an artist's writing did not end up making a picture smaller, less complex, less resonant, less worthy of comparison with life.

Part of the reason that these attempts at explanation fail, I think, is that photographers, like all artists, choose their medium because it allows them the most fully truthful expression of their vision. Other ways are relatively imprecise and incomplete. Why try the other ways? As Charles Demuth said, "I have been urged . . . to write about my paintings . . . Why? Haven't I, in a way, painted them?" Or as Robert Frost told a person who asked him what one of his poems meant, "You want me to say it worse?"

Photographers are like other artists too in being reticent because they are afraid that self-analysis will get in the way of making more art. They never fully know how they got the good pictures that they have, but they suspect that a certain innocence may have been necessary. The poet X. J. Kennedy speaks of this in his amusing verse "Ars Poetica":

The goose that laid the golden egg
Died looking up its crotch
To find out how its sphincter worked.
Would you lay well? Don't watch.

The main reason that artists don't willingly describe or explain what they produce is, however, that the minute they do so they've admitted failure. Words are proof that the vision they had is not, in the opinion of some at least, fully there in the picture. Characterizing in words what they thought they'd *shown* is an acknowledgment that the photograph is unclear—that it is not art.

Of course if you believe in the merit of your work you reject the accusation of failure that is implied by a request to explain it. In this respect all artists are elitists. They are convinced that some viewers lack patience to see what is clear.

Probably the best way to know what photographers think about their work, beyond consulting the internal evidence in that work, is to read or listen to what they say about pictures

made by colleagues or precursors whom they admire. It is as close as photographers usually want to come to talking about their own intentions, though even this testimony must be interpreted carefully because it is guarded (no one undergoes the trouble of serious picture making if he or she believes that anybody else has done exactly what most needs doing). Almost all photographers admire a selection of work by others, though, and sometimes the achievements they notice are closely related to their own.

For photographers, the ideal book of photographs would contain just pictures—no text at all. There have been a few volumes like that, but publishers complain they don't sell, so not many have been allowed, which leaves photographers to endure the botched clarity and wasted effort required of them. (Writing under the best of circumstances is demanding; Red Smith, the eminent sportswriter, addressed everybody who supposes otherwise: "There's nothing to writing," he said, "all you do is sit down at the typewriter and open a vein.") I remember once working through more than a hundred drafts of a four-paragraph statement for a catalog, all to find something that would just keep out of the way of the pictures.

Things are not about to improve either. University presses, for example, which publish some of the best photography, hold increasingly to a policy that requires books of pictures to incorporate "substantial" texts. This often means not only layering together pictures with the photographer's words, but also sandwiching the concoction between slabs of social-scientific balloon bread.

Photographers continue to write because they need to have their pictures reproduced in quantity; it is the only way they can convey an adequately sized vision of things. To get published I have tried every kind of cheating—I have quoted others to the same end as mine, I have talked about

photography in general in order to imply what I was attempting personally. Experience has shown, however, that the best way to avoid talking about the pictures is to talk about their subjects—tract houses or fields or trees or any of the myriad and interesting details of life. If you have to fill the quiet of a picture, the least destructive way seems to be to speak about what was in front of the camera rather than about what you made of it. It seems the least a trick, the closest you can get to speaking about the meaning of a picture without actually doing so.

C. S. Lewis admitted, when he was asked to set forth his beliefs, that he never felt less sure of them than when he tried to speak of them. Photographers know this frailty. To them words are a pallid, diffuse way of describing and celebrating what matters. Their gift is to see what will be affecting as a print. Mute.

TEACHING

I really didn't have much to teach. I didn't even believe in it. I felt so strongly that everybody had to find their own way. And nobody can teach you your own way. . . . In terms of art, the only real answer that I know of is to do it. If you don't do it, you don't know what might happen.

—HARRY CALLAHAN, 1991

FEW ARTISTS want to teach. Part of the cruelty in George Bernard Shaw's famous aphorism—"Those who can do, and those who can't teach"—is that it fails to distinguish between those without the gift to do something else, and those without the money.

Another unfairness is its suggestion that teaching is a less important calling. Most people alive in the United States today have never had, for a variety of reasons, the full attention of a first-rate teacher, and our democracy is failing partly as a result.

Many artists have been conscientious teachers. Poet Theodore Roethke, architect Louis Kahn, painter John Sloan, and photographer Harry Callahan all earned the gratitude of students. It isn't surprising. Art requires empathy and a

sense of wholeness, qualities of spirit that lead naturally to a concern for the young.

Most artist/teachers divide their time uneasily, however, and over the years relegate one or the other pursuit to second place, if only in their hearts. Some quit making art or teaching altogether, and if it is teaching they abandon it can be with a sense of stunned exhaustion. "I still dream I must teach," D. H. Lawrence wrote, "and that's the worst dream I have."

Why was it so bad? It is tempting to dismiss such complaints as those that accompany any hard job, but the truth is that for people with a professional agenda outside the classroom teaching carries special burdens. I remember helping the widow of a Shakespeare professor of mine sort through the contents of his study, and finding there cartons of unfinished manuscripts for novels. He had, under constant pressure to analyze other people's writing, never brought his own to completion. I had been aware that in his brief retirement he had tried "creative" writing (as distinguished from critical commentaries, at which he was brilliant), but I had no idea the attempt had gone on all his life, or so fervently. Could he really have suffered such a divided focus? As a friend observed when we took some of the boxed material to a landfill, our professor had been one of those rare teachers whose gift for and commitment to his job changed many lives. His example was in fact why we ourselves had become teachers.

Before our professor died, however, he told us that what he respected most in us was our decision to quit (my friend to write and I to photograph). It was a declaration of such complexity that he and we made light of it—we suspected that he wanted to spare us any sense of having failed him— though his wife confirmed later that he meant what he had said. He had desperately wanted to create art rather than to deliberate on the art of others.

This was not the first time I had encountered extreme frustration in the profession. Of the seven people in the English department where I began teaching, two took their lives, one as the direct consequence of depression over his inability to balance teaching and writing (he had hoped to be a poet, but found that teaching wore him out). The morning after his passing, the dean, a kindly man near retirement, remarked to a group of us that he thought suicide was an occupational hazard. He may have been right. Responsible teaching is an all-out effort. Only a maximum of patience, imagination, and zeal can make an effective case to students for caring. The best of them always want more than just facts; they want to see an example of how to live with the facts, and perhaps even by them. But against the students' need it is hard to pace yourself, to remember that helping them depends sometimes on turning away.

When I have been asked to teach photography I have found myself puzzling over three questions: Can photography be taught? Ought it to be taught? If so, am I the one to teach it?

Can photography be taught? If this means the history and techniques of the medium, I think it can. The latter, particularly, are straightforward. If, however, teaching photography means bringing students to find their own individual photographic visions, I think it is impossible. We would be pretending to offer the students, in William Stafford's phrase, "a wilderness with a map." We can give beginners directions about how to use a compass, we can tell them stories about our exploration of different but possibly analogous geographies, and we can bless them with our caring, but we cannot know the unknown and thus make sure a path to real discovery.

Ought photography to be taught? If at the beginning of my own photography I had taken a course in the mechanics, it

would have saved time. Learning the history of the medium might also have been done more systematically in a class, but it was fun and easy to do on my own. As for studio courses in "seeing"—which usually place student work up for evaluation by both classmates and teachers—I was never tempted to take one, and so am not attracted to teaching one. Arrogantly I believed right from the start that I could see. That was the compulsion, to make a record of what I saw. And so listening to most other people speak didn't seem helpful. Even now I don't like to discuss work that isn't finished, because until it is revised over the span of a year or several years there are crucial parts that are present only in my mind's eye, pieces intended but not yet realized. If I were forced to pay attention, as one would be in a class, to a dozen different understandings and assessments of what I was putting together it would amount to an intolerable distraction, however well meant. Architect Luis Barragan was right, I think: "Art is made by the alone for the alone."

Am I one to teach photography? When I consider the possibility I can't help remembering a question put to me by an affectionate and funny uncle when I told him I might become a minister—"Do you have to?" Experience later as an English teacher brought up the same issue. Teachers must, I discovered, have a gift to teach and the compulsion to use it. And faith. Anything less won't carry you through. There were times, for instance, when teaching came to seem to me "just a phony kind of theater" (as the filmmaker Emilio Antonio once called it). With that, I faltered.

Having quit English teaching, I felt it would be foolhardy to try photography teaching. Darkroom work had, after all, never interested me except as a means to an end; the place I wanted to be was outside in the light. I suspected, moreover, that I didn't really care about the history of the medium except as it inspired and set rules for my own pho-

tography. Certainly I knew I didn't want to study at length my contemporaries' pictures, fearing that their work might come close to mine and blur my vision.

As has often been pointed out, the scholar's task is relatively analytic, whereas the artist's is synthetic; academics enjoy disassembling things in order to understand how they work, whereas artists enjoy taking scattered pieces and assembling from them things that do work. Each activity is legitimate and conceivably reinforces the other, but there are not many people in whom the enthusiasms are balanced.

I think my Shakespeare professor experienced some of these conflicts. I hope he knew, better than I understood then, how grateful I would be that he didn't leave us.

MONEY

 . . . I *dream of a clean wood*
shack, a sunny pine trunk, a pond, and an independent income:
if light warms a piney hill, it does nothing better at the
farthest sweep of known space . . .

 —A. R. AMMONS

MONEY is important. It allows you the power over your-self—your time, your energy, the place you live, the tools you have—to be yourself, to get the job done.

•

"For money, even the dogs will dance." What a satisfying aphorism that is in its perfect bitterness. But toxic to the speaker if repeated too often.

•

Part of the difficulty in trying to be both an artist and a businessperson is this: You make a picture because you have seen something beyond price; then you are to turn and assign to your record of it a cash value. If the selling is not necessarily a contradiction of the truth in the picture, it

is so close to being a contradiction—and the truth is always in shades of gray—that you are worn down by the threat.

·

When a photographer dies, her or his negatives are usually of little interest because prints depend for much of their "value" on the photographer's signature. We could assemble wonderful collections, however, if we freed ourselves from this marketplace tyranny. Yes, we would want to be careful to try to determine whether posthumous prints fulfill the artists' intent, but if it is the pictures we love (as distinguished from the possibility that they might appreciate as investments, or serve as curatorial trophies) then the adequacy of posthumous restrikes can often be determined by common sense and the testimony of our eyes. In the 1970s Kerstin bought for me from the Oakland Museum for thirty-five dollars a print made from the original negative of Dorothea Lange's *Woman of the High Plains*. It is among the most beautiful photographs I own. And given that Lange was not, by her own admission, an enthusiastic or confident darkroom worker, my guess is that this rendition, made by an exceptionally skilled employee of the museum, is as good or better than any she made herself. I am rich to have it.

·

Of all the cuts in funding for photography by the National Endowment for the Arts, by far the worst was to stop support for the publication of photographers' monographs. Such books rarely pay for themselves, but they are absolutely necessary to the health of the medium. They allow work to be seen in quantity, to reach a geographically diverse audience, and to be encountered over a period of time. I know of no first-rate photographer who has come of age in the past

twenty-five years who has found the audience that he or she deserves without publishing such a book.

·

When it was suggested to the poet Philip Larkin that he earn a living by giving readings and lectures, he answered as would many photographers who have contemplated doing the circuit: "It would embarrass me very much. I don't want to go around pretending to be me." Self-imitation has been avoided by those who are especially gifted and rigorously in control of their egos—who, for example, does not enjoy hearing Eudora Welty read?—but for most artists public lecturing quickly leads to foolishness.

·

Auctions held to benefit photographic institutions rely substantially on work solicited as gifts from photographers, many of whom cannot themselves earn a living wage from their pictures. The health of some of the organizations contributes to that of photography in general, and thus to that of the photographers individually, but one cannot help thinking how much more charitable it would be if those who could afford to do so would first buy the prints from the photographers, perhaps at wholesale, and then themselves donate the work for auction. Isn't it a little questionable to beg the prints for nothing, attract people to the auction by listing estimated bids below gallery prices, and then relish bargains? Because afterwards the cut-rate prices are a matter of public record, and erode the photographers' attempts to maintain regular prices—so much so that it would probably be more in the photographers' interests sometimes just to contribute money rather than pictures.

·

When I talk with young photographers there is often a moment when I know what is on their minds, something about which they are too polite to ask—how have Kerstin and I survived financially? I tell them that Kerstin has had the steady work, that I have sold prints when the times have allowed it, and that there have been some grants. And then I try to tell them that it has been good to work hard, that work has been one of the best and perhaps most saving things in life. Although I also have to admit that they will become tired, and that if they have money, the money will never become tired.

·

How much money would be enough? It's a theoretical but sobering question, so strong is the temptation to believe that one might buy one's way past the nature of life.

·

"Like most composers, Schoenberg had more or less constant money problems. The thought arises whether these are not the true subject of music." (John Cage)

From notes, 1967-1992.

DOGS

To be without a dog is worse than being without a song.
—Henry Beetle Hough

WHERE does art begin? Photographs of Thomas Eakins and Pierre Bonnard with their dogs (plates IX, X) suggest, I think, an answer. For these artists in their old age to touch animals so gently is evidence of a love past memory, one that must have shaped their lives.

Both presumably came to their fondness for dogs out of a variety of human impulses and understandings—a need for loyalty, for instance, and a sense of the dog's own dependence. My guess though is that what sustained the artists' affection for dogs was above all the animals' enlivening sense of possibility. Artists live by curiosity and enthusiasm, qualities readily evident as inspiration in dogs. Propose to a dog a walk and its response is absolutely yes. As a terrier of ours once exclaimed to Kerstin, in a dream of hers, "Let's, Kerstin!" Those were the only words that anyone had ever heard the dog speak—a wide-open program of unqualified eagerness, delivered from her characteristic posture of readiness to bolt for the kitchen, town, or field.

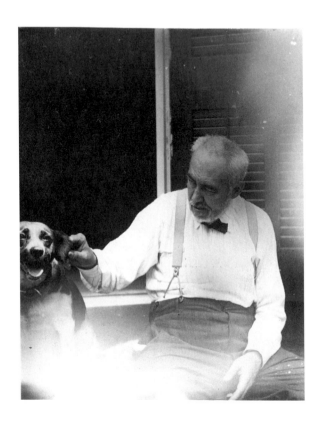

IX Photographer unknown, *Thomas Eakins at about Age Seventy*, ca. 1914

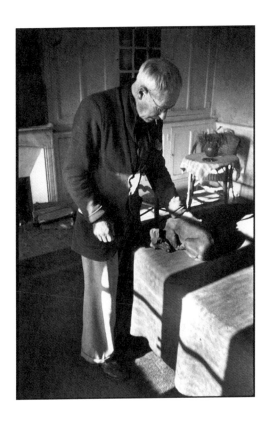

X Henri Cartier-Bresson, *Pierre Bonnard at Age Seventy-eight,*
with Poucette, at Home in Le Cannet, 1945

"A dog loves life as the young love it," Henry Beetle Hough wrote, "always and always."

Of course dogs are not humans, and so our communion with them is limited. Apparently no dog can abstract, at least at anywhere near a human level. None can achieve that kind of freedom and thereby enjoy that opportunity for choice, and thus, it would seem, for virtue. Nevertheless we appreciate the peace we see in animals. It is, if not a moral achievement (though it may be), a precious gift to them and thereby to us. To watch and listen to a terrier eat, for example, is to guess at what enlightenment might be for people: "When I eat I eat, and when I drink I drink."

Eakins and Bonnard confirmed their long affection for dogs by the photographs each made of them. Only those by Bonnard seem often to have influenced the artist's paintings (and prints), although a photograph of Eakins's dog Harry must have contributed to the portrait that Eakins did of his wife, Susan, with a dog at her feet (plates XI, XII). In other paintings by Eakins, however, we can sense the presence of a dog even when we cannot see one. How else would such unsparing pictures have been bearable for either subject or artist if there hadn't often been the sound of a dog shambling through the studio, nosing up to people, or, outside, the sight of one enjoying the feel of the sun and grass? Look at the way Harry relaxes Margaret Eakins (plate XIV) so that she can allow her brother to see her as she is, a lovely but rumpled Arcadian. As the dog frees her from self-consciousness, and thus frees the photographer from that obstacle, he can go on to recognize in his human subject a truth as specific, complete, and radiant as the truth she feels in the animal she holds.

I think we have been too quick to dismiss what city people can know about nature. Their deprivation may actually help them to see better the few animals that they are

allowed, and to experience with compensatory depth those occasions when they are permitted to visit the country. Consider as evidence these lines by William Stafford:

> I *drink it for luck, that star in*
> *my cup, after the campfire goes out.*
> *In the morning I feel great. See, the*
> *sun follows me like a big dog.*

Art depends on there being affection in its creator's life, and an artist must find ways, like everyone else, to nourish it. A photographer down on his or her knees picturing a dog has found pleasure enough to make many things possible.

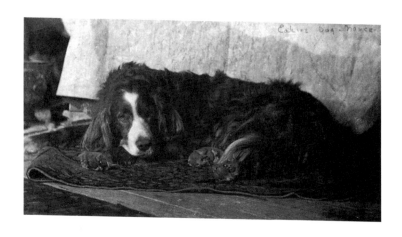

XI Thomas Eakins, *Harry*, ca. 1880-1885

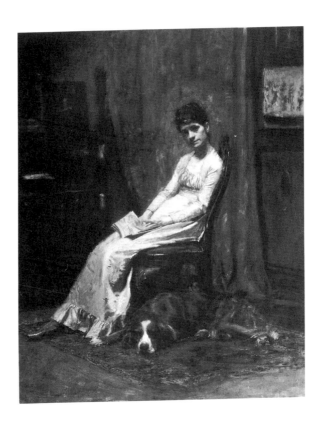

XII Thomas Eakins, *Portrait of a Lady* (Mrs. Eakins)
with a Setter Dog, ca. 1884-1888 (painting)

XIII Pierre Bonnard, *Andrée Terrasse Playing with the Family Pets*, 1898

XIV Thomas Eakins, *Margaret Eakins with Harry*, 1880

EXAMPLES OF SUCCESS

XV Edward Weston, *Cypress Grove*, 1938

EDWARD WESTON

BIOGRAPHY was given its best defense by Samuel Johnson, who wrote that it ought, along with being interesting, to tell the truth:

> *If nothing but the bright side of characters should be shown, we should sit down in despondency, and think it utterly impossible to imitate them in anything. The sacred writers . . . related the vicious as well as the virtuous actions of men; which had this moral effect, that it kept mankind from despair.*

Biographies thus give us "what we can turn to *use*."[1]

As a subject for biography, an artist requires a particular method of approach, I think, because, as Aristotle observed, the artist is distinguishable from the mentally ill (among whom Freud numbered us all) only by the fact that he manages occasionally, through his art, to escape the sick person's distorting, isolating perspective. It is therefore the artist's *work*, set against the life, that tells us how, in a mea-

Originally this essay appeared under the title "The Achievement of Edward Weston: The Biography I'd Like to Read," in EW 100: *Centennial Essays in Honor of Edward Weston*, edited by Peter C. Bunnell and David Featherstone, published by the Friends of Photography in 1986.

sure, he escaped failure; thus it is the work that we must study if we are to learn something useful.

All but one of the recent biographies of photographers leave me embarrassed at having listened to things for which there is, on the basis of the books, scant justification to listen. Gossip. Only John Szarkowski and Maria Morris Hambourg's critical biography of Atget (about whose private life, like Shakespeare's, there is helpfully scant information) keeps the work foremost and uses it to illuminate the life, balancing the inevitable compromises in the life with the achievements in the art.[2] Patricia Bosworth, who was denied permission to reproduce Diane Arbus's pictures, apparently felt it was impossible to discuss them, and so presents in her book only the story of a compulsive rich girl who destroyed herself. Milton Meltzer's biography of Dorothea Lange, which is almost as negligent of its subject's work, except when Meltzer quotes others who cared about it, tells chiefly the story of an unsuccessful mother who is self-deceiving. Ben Maddow's biography of Edward Weston, though it contains perceptive remarks about some of the pictures, focuses on Weston's love affairs.[3]

As a practical matter, it seems to me that the biographer of an artist ought not only to begin with a commitment to use the subject's work as primary evidence, but to remember the nature of Aristotle's argument for its centrality—that it is a unique curative for sickness—and assume that art begins in unhappiness. True, the goal of art is to convey a vision of coherence and peace, but the effort to develop that vision starts in the more common experiences of confusion and pain. Which is to say that if we are to use the artist's work as our evidence about his life, we must, to some degree, turn it around and find the negative that stands behind the positive. If a work shows a beautiful woman or an orderly landscape, the biographer ought to

inquire about the nature of the world in which the artist usually felt he lived, the one he struggled to place in a more affirmable perspective.

What I would really like to know from a biography about Edward Weston—I hope a major one will be written someday—is where the greatest pictures came from. I think they did not necessarily come from the sometimes foolish man who was a vegetarian but enjoyed bullfights, the one who believed in astrology and wore a velvet cape. They must have come from a more thoughtful person, one who suffered enough to learn.

Maddow begins his biography with a description of the room where there are stored the "remains of Edward Weston's mind"—first the "negatives . . . sample prints, [and] bound portfolios of his work," and second, "family records, boxes of letters, . . . [and] his journals."[4] To these, Maddow says he will add "the memories of those who knew him" in order to "give us a necessary third dimension," encouraging us to believe that the list represents the order of importance in which he holds the evidence. We read many pages into the biography, however, before we come to substantial references to specific pictures, and such references remain scarce throughout the book.

One wonders why biographers, who usually begin their studies out of enthusiasm for their subject's art, so often quickly turn away from the art. The answer seems to be that they do not share enough experience with their subjects, and so are unable to reconstruct the origin of the work. Maddow tries to describe, for example, as if from Weston's perspective, the act of photographing, but the description fails to come to life. He offers few insights into a photographer's particular approach to the world, insights like those Szarkowski, who was a photographer for twenty years, gives

us in his discussion of Atget when he notes the special interest to photographers of a few days in spring when leaves are green but not fully out, days that allow a record of both light and structure. Maddow just does not know enough about the act of working with a view camera, for instance, when he concludes that the Guggenheim land-scapes in California were seen by Weston as a motion-picture cameraman would see a tracking shot, as "a continuity of experience rather than an intensification."[5] Months of setting an 8 x 10 camera up and down would probably disabuse him of that interpretation. Put more generally, it seems to me that there are relatively few great biographies of visual artists because great biography is motivated by a kind of constructive envy, and is usually written in the hope of emulating the subject's achievements. A writer, or even a sometime moviemaker like Maddow, is unlikely to envy a still photographer in the way or to the degree that he would envy another in his own profession.

The problem with Maddow's biography is not that he is insensitive to the photographs—he writes briefly but com-pellingly about the beauty of the shell pictures, for instance.[6] And the book as a whole is not simple; Maddow notes a dark side to Weston, depressions that occurred often, and in puzzling contexts. When Weston's pictures were reviewed enthusiastically in Mexico, for example, Weston is quoted as writing that he "became obsessed— overwhelmed by the desire to quit."[7] This is an experience common to artists, but rarely in that degree. Maddow notes some possible contributing factors to the depressions—his mother's death when he was five, his sister's extremely high expectations for him, and the financial problems that never let up—but none is shown to account for the severity of the depressions, especially when they are linked to the unusual shape of Weston's career, one in which he drastically

reinvented himself several times, going from pictorialist to modernist to landscapist. These changes, together with his destruction of many letters and notes, suggest a depth to Weston's struggle that remains unexplained.

If we use Weston's pictures as evidence about the nature of his life, what might the pictures tell us? By way of example—and only that—I would like to look briefly at three truisms about Weston that might be open to modification or better explanation if we put them more firmly in the context of his work.

Consider first the apparently indisputable fact that Weston loved many women. Maddow traces his affairs mainly on the basis of letters and the testimony of friends, but if we add to these the nudes that Weston took concurrently, the impression we have of the quality of the affairs is altered; Maddow alleges that "love and photography was a combination that was natural to him all his life," and that "the results were effective on all counts,"[8] but the evidence of the pictures contradicts this. With the exception of two full-length nudes of Tina Modotti in Mexico, and five of Charis Wilson in the Oceano dunes (not many, considering the number of nudes Weston took), the pictures that supposedly resulted from Weston's love for his subjects are, relative to the rest of his life's work, unsuccessful; they are cold to the point of being dead—a crucial flaw in pictures of *people*, who are animate—and thus unattractive on any but the most icily aesthetic terms. As Maddow describes them, though he does not himself call them failures, "more and more, his nudes became examples of strict . . . form";[9] of the ones from the late 1920s and early 1930s he observes, "the compositions are markedly influenced by vegetable and banana forms."[10] Weston himself acknowledged that "I have had a back (before close inspection) taken for a pear."[11]

Kenneth Clark suggested, rightly I think, that pictures of nudes must, to be successful, "arouse in the spectator some vestige of erotic feeling."[12] Weston, for his part, disagreed. And he vehemently, and correctly, denied that his nudes were erotic. Erotic art evidences, however obliquely, a degree of sexual desire by the artist for his subject, and Weston's nudes do not, except for those noted, evidence much desire at all. The limbs and torsos and whole figures are treated as shapes to be enjoyed as one might the sight of a smooth stone.

Presumably Weston defended his nonerotic nudes as successful because he felt that the human body presented, as Clark described it, a problem.

> The body is not one of those subjects which can be made into art by direct transcription. . . . Naked figures [do] not move us to empathy, but [to] disillusion and dismay. We do not wish to imitate; we wish to perfect. . . . Photographers of the nude are presumably engaged in this search, . . . and having found a model who pleases them, they are free to pose and light her in conformity with their notions of beauty.[13]

Clark goes on to say that the photographer's effort, which he implies is unlikely to succeed, must be toward achieving "the harmonious simplifications of antiquity," which is done by eliminating the model's "imperfections."

While one can sympathize with a photographer's attempt to confront so unresolvable a problem as eliminating imperfections while not eliminating life, one must also note that when the effort is carried to an extreme, as it seems to me Weston carried it when he photographed people as if they were botanical, the solution can amount to a human failing, one that presumably should interest a biographer. Especially when the solution is applied, as the daybooks testify and as Maddow notes but does not develop, just before having sex with the model (the reverse being, as Maddow

observes, probably the more common order). And especially when it usually involves cropping or turning away the face of the model.[14]

I am not qualified to sort these matters out (Weston was doubtless partly right when he complained that "the only thing critics do is psychoanalyze themselves"), but what seems clear on the basis of the pictures is that Weston was inclined to treat the bodies of his lovers as things free of individual personality—an inclination not too different from that of pornographers, though the results are in some ways dissimilar—and imperfectly related to Weston's statements of affection for his models. When one contrasts the cold pictures he made of them with the picture he took of Jean and Zohma Charlot embracing (plate XVI), one wonders if that portrait, in its eroticism, was not Weston's best insight into what so often eluded him.

It might be argued that the nudes, with their implication of Weston's limitations, show us nothing that the daybooks don't. The nudes, however, unlike the occasionally self-serving notebooks, show the condition as its own judgment. The pictures, by which Weston measured his achievement as an artist, are most of them dull, and I think even Weston must have suspected this at times.[15] But beyond the artistic failure there is the evidence they carry of personal failure. The nudes record not desire, but a sad sort of invention and staring. A biographer who directs our attention to the pictures is saved any need to moralize.

Another truism we might consider in the context of Weston's pictures is that he was politically withdrawn. As Henri Cartier-Bresson is reported to have complained, "The world is falling to pieces—and Weston [is] . . . doing pictures of rocks!"[16] Weston himself contributed to this

overly simple view of himself when he said things like "I have been a [nonpolitical] anarchist since my twenties."[17]

Using other quotations from Weston, however, Maddow establishes that he was not politically thoughtless; he disliked capitalism for its encouragement of greed, and communism for its abuse of the individual. Nor was he uninvolved in the political events of his day, having participated briefly in the WPA, written letters to newspapers against the internment of Japanese-Americans, and served as an airplane spotter during World War II.

Maddow is puzzled, however, by the fact that Weston was especially unhappy around the time of the war:

> . . . the astonishing [my emphasis] fact is that, in the midst of this full and happy and famous year [1940], Weston's photographs were, a good half of them, anyway, quite frankly funereal. Many are studies of cemeteries; . . . even the landscapes and the houses are dank and decayed. . . . One speculates [my emphasis] in what way Edward Weston had become deaf and brooding and fixed upon the eternal.[18]

I think Maddow's astonishment puzzling. Weston, it seems to me, heard well enough. His sadness may in part reflect the unrecognized but experienced onset of Parkinson's disease, and it must, to some extent, be attributable to the deterioration of his marriage to Charis Wilson, but surely there is also the fact that by 1940 many thoughtful people, among whom there is no justification not to include Weston, believed that a world war had become inevitable. Auden could, after all, write in 1939 that "the clever hopes" of the decade were expiring, and no one found his sadness a cause for mystified speculation. Weston cherished, one remembers, four sons who were of draft age.

What might the pictures bring to the common misapprehension of Weston as apolitical, and to our understanding

XVI Edward Weston, *Jean Charlot and wife*, 1933

of Weston's depression at the time of World War II? Maddow is disturbed by the grotesque pictures that Weston made around the house during the war, such as that of Wilson nude except for a gas mask. Common sense suggests, I think, that they expressed an anguish that originated in part from the war, in addition to the fact that the pictures were in certain respects made out of necessity (gas rationing meant no travel, and Point Lobos was occupied by the military), and despite the fact that Weston defended them on the same grounds as his other work. The pictures have no parallel in Weston's other work, they are certainly neither funny nor beautiful, and they are not, as Weston tried to claim, a case of an artistic breakthrough initially misunderstood (at least I know of no one to this day who likes them). It is right that we are disturbed by them; they demonstrate the cost of living in this century.

Of more importance, though, are the pictures he tried to make when opportunity allowed. In 1940, for example, he set out to attempt work, on commission, that would accompany an edition of Whitman's *Leaves of Grass*, to photograph in accord with the most famous of all hymns written in honor of this country. He continued the effort, until America's actual entry into the war forced him to stop, despite the evident fact that, though he traveled long distances, the pictures were less successful than those he took on Point Lobos. A person like that would have to be, I think, one who cares, even if without hope, for his nation.

Beyond that, consider the pictures he made at the close of the war—for instance the one, beautiful and terrible at once, of the pelican floating dead in the tidal wrack, as if carried home from the Pacific conflict. Think too of the pictures he made of his boys out on the rocks, in the celebratory sun. And above all of the picture of Brett and his daughter Erica (1945), she with her doll and he with his

hand around her shoulder, both thinking their own thoughts but both depending on each other. Weston's early (1925) picture of Neil on the couch, an aesthetic triumph made at the cost of using his son while the boy suffered from a migraine, would never have been repeated by the time Weston took the one of Brett and Erica. The later picture was taken by a man who, it seems to me, had watched for four years as parents and children had been forcibly separated forever.

A consideration of Weston's political awareness in light of the pictures he made suggests, then, that he responded to social issues with personal concern and ultimately with a renewed commitment to work and to life. Part of this was expressed as a deepened commitment to individuals around him, a change that was itself, at a time when things were already being measured more and more by their mass effect, a political act.

A final truism we might consider with the pictures in mind is one that Maddow repeats from others—that the late photographs made at Point Lobos are comparable "to the last quartets of Beethoven."[19] "This is very apt," Maddow observes, "in the sense of their dark complexity." It is not their complexity, however, but their darkness that seems most important to him: "The black-and-white photographs he took during this time were black indeed; eroded rock on black sand; trees gripping into a black cliff"[20]—all seeming to picture, Maddow suggests, death. By the end of the biography, in fact, Maddow questions their complexity. He writes that Point Lobos was, before Weston showed it to us, a "confused upheaval," but that it had "a beautiful order imposed upon it by Edward Weston."[21]

Setting aside the question of the degree to which the order Weston showed us was imposed or discovered, I

XVII Edward Weston, *Eroded Rocks, South Shore, Point Lobos*, 1948

think that in the later pictures at Point Lobos there is less of an obsession for order than in the earlier ones. John Szarkowski has made this point about the relatively late (1937-1938) Guggenheim landscapes as a whole. "The photographer's authority is maintained with a looser, gentler rein. A sense of the rich and open-ended asymmetry of the world enters the works, softening their love of order."[22] In the case of the pictures taken over the years at Point Lobos, this can be noted in a general way in Weston's increased production of long shots, and the inevitable lessening in control over the subject that this involved. The change can also be observed by comparing pictures of relatively similar subjects, as for example the best-known shots of rock walls, in which Weston attained freer, subtler composition as the years passed.

The loosening toward complexity is apparent, too, in the development from the earlier pictures of single beach rocks—whole, smooth—to the last picture that Weston made in 1948, with rock fragments, almost shards, scattered at the borders of the frame. Also relevant is Weston's increased willingness to photograph the shifting expanse of the sea itself, and even breaking waves; not since Mexico, when he had recorded animated faces (Galvan shooting, Tina reciting, Guadalupe talking) had he so often accepted into pictures what could not be precisely foreseen or controlled.

The biographical importance of the last pictures seems to me not so much that they show us Weston's awareness of death, but that they demonstrate the personal achievement of Weston's life, the achievement of which Beaumont Newhall wrote after seeing Weston in a late stage of his illness: "He had accepted his fate and was resolved to bear it."[23] The progressively relaxed compositions of his later pictures testify to a willingness to affirm life on other than selective terms. They show the peace that is evident in his last letters

to friends, letters as beautiful as any of which I know—brief, colloquial, dignified, and urgent with affection.

Running through much of Weston's life was an engaging spirit of celebration, and that also grows in the late Point Lobos pictures. While I'm not sure I can describe its expression convincingly, I think I see it in the photographs—a new sensitivity to light, to light just in the air, especially to light as it is caught by shooting into the sun. Whereas in most of his work he had used light as it came from behind or to the side of him and fell on objects so as to model their shapes, and whereas in his earlier landscapes the sky tended to be used for the shapes it formed or held—for the horizon line, or the clouds—there are times in the later years when the substance of the sky, occasionally blank, seems to fascinate him almost in itself. Though such a thing is virtually unphotographable, in combination with his interest in trees and rocks and land forms it begins to result in views that are newly radiant and that, as never before, invite entry. I think, for instance, of *Cypress Grove*, 1938 (plate XV), with its ragged trees in thick, luminous, coastal air. What an extraordinary day.

If, then, we are led eventually by a full-scale biography to combine what we might learn from Weston's pictures about, among other things, the three truisms—that he was a prodigious lover, that he was apolitical, and that his final landscapes are especially significant—might we not see more clearly the nature of Weston's achievement? As remarkable as was his creation of the pictures—and perhaps to some degree through that—he appears to have become, after many failed attempts, another person, growing away from his earlier egoism and its disappointments toward a more generous view of other people and of the world as a whole.

1. James Boswell, *Life of Johnson*, vol. IV, Birkbeck Hill ed. (Oxford, 1950), 53.

2. John Szarkowski and Maria Morris Hambourg, *The Work of Atget* (New York: Museum of Modern Art, 1981-85).

3. Patricia Bosworth, *Diane Arbus: A Biography* (New York: Knopf, 1984); Milton Meltzer, *Dorothea Lange: A Photographer's Life* (New York: Farrar, Straus & Giroux, 1978); Ben Maddow, *Edward Weston: Fifty Years* (New York: Aperture, 1973).

4. Ben Maddow, *Edward Weston* (New York: Aperture, 1978), 9. All further citations from Maddow's biography are from this paperback edition.

5. Maddow, 110.

6. Maddow, 77.

7. Maddow, 57.

8. Maddow, 50.

9. Maddow, 73.

10. Maddow, 93.

11. Peter C. Bunnell, ed., "Form," *Edward Weston on Photography* (Salt Lake City: Peregrine Smith Books, 1983), 158.

12. Kenneth Clark, *The Nude: A Study in Ideal Form* (New York: Doubleday, 1956), 29.

13. Clark, 25-27.

14. In discussing the nudes of Modotti, Maddow notes that one he admires is "almost unique; it has both the beloved's face and her sex," which he notes is "rare for Weston, perhaps as much for psychological as compositional reasons" (63). Maddow does not, however, pursue the insight.

15. Weston was all his life uneasy about the degree of abstraction that was appropriate in art. In a famous passage in the *Daybooks*, for example, when he contemplated the success of his Mexican portraits (many of which are, it seems to me, erotic), he was brought to write, "I shall let no chance pass to record interesting abstraction, but I feel definite in my belief that the approach to photography is through realism" (Nancy Newhall, ed., *The Daybooks of Edward Weston*, vol. I [Rochester: George Eastman House, n.d.], 55).

16. *Time*, 3 Sept. 1979, 44.

17. Maddow, 109.

18. Maddow, 111.

19. Maddow, 97.

20. Maddow, 117.

21. Maddow, 122.

22. John Szarkowski, "Edward Weston's Later Work," Beaumont Newhall and Amy Conger, ed., *Edward Weston Omnibus: A Critical Anthology* (Salt Lake City: Peregrine Smith Books, 1984), 159.

23. Maddow, 120.

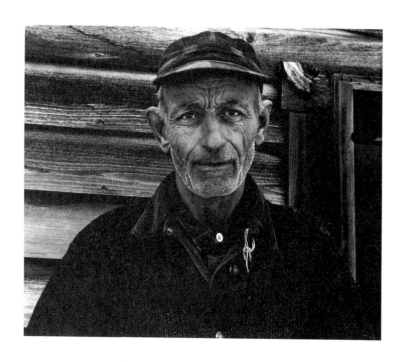

XVIII Paul Strand, *Mr. Bennett, Vermont,* 1944

PAUL STRAND

WHO CAN SAY what amalgam of memory, dreams, study, pain, and discipline brought Paul Strand to photograph Mr. Bennett and to record him so perfectly? The picture is almost as unaccountable as the fact of Mr. Bennett; we are left with our little cosmologies and the certainty that we will never fully know. But we continue to speculate, as we do with all great art, because the picture is clearer than life and in this consoling.

In the case of Strand's work, which seems to me especially important not only because of its high quality but because it is out of fashion among photographers, my guess is that the most shaping force in his creative life was his devotion to America, a commitment as deep and troubled as that of his teacher, Alfred Stieglitz, and kept as faithfully to the end.

Such a thesis, from the perspective of most artists who have lived through the recent history of the United States, seems almost categorically unbelievable. Could anyone

First entitled "Strand's Love of Country," this essay was included in *Paul Strand: Essays on His Life and Work*, edited by Maren Stange, published by Aperture in 1990.

have loved this sad country with its unnumbered ironies so much that a regard for it would be the foundation of a life's work? If we explore the widely held and I believe defensible judgment that *Time in New England* contains Strand's finest body of pictures, it becomes clear I think not only how important but also how indirect a devotion to country can be in art.

It is the indirection on which I wish to focus, but there is the obvious with which to begin: When Strand did most of the photographs for *Time in New England* (1943-1947), we were at war or just recovering from it, and he was an idealistic humanist who shared many of the country's goals. What could have been more appropriate than picturing the area where the United States began, a place geographically beautiful, rich in traces of the nation's past, and inhabited by citizens of evident character?

Having acknowledged the logic in his choice of subject, however, it is another matter to account for the art. What separates *Time in New England* from hundreds of calendars and illustrated books showing the same material? Generally, it is the freshness, depth, and scope of Strand's pictures, but how was this achieved, and why did he take the pains?

Photographs as exceptional as Strand's originate, I think, in personal need, in an urgency to find what the artist has to have to be at peace (the mediocrity of much assigned work results from the lack of this compulsion). The necessity builds, sometimes from wholly private, individual factors, but often from the way these relate to the social context, until the artist is forced to take the risk of making something untried.

A part of what brought Strand to make the New England pictures was presumably psychological. Those to whom I have talked who knew him describe him as difficult—which

suggests, as do his three marriages, that like most artists he was driven by inner and idiosyncratic burdens. But of these we can know little in the absence of a major biography.

Even if most artists work first from a sense of obligation to themselves, however, they usually believe that if they answer their private demands they will in the course of doing so also fulfill their duty to others. It is a risky and arrogant proposition, defensible only after the fact of successful pictures, but it is an attitude as common to the calling as is the brittle behavior of its adherents.

Strand's need to make the New England pictures was, it seems to me, both personal and altruistic. He had spoken life-long in support of America's emphasis on the worth and dignity of human beings and had worked in the 1930s and early 1940s as a filmmaker, trying there to address the crisis in values that the nation had experienced through the Great Depression and the Second World War. He had, however, participated neither in the Farm Security Administration's successful documentary photography program nor directly in the war, and he must have realized that his motion pictures were not going to reach a continuing audience. He needed, presumably, to do better. Like many of the best photographers who came of age professionally in the 1920s and 1930s—Ansel Adams, Dorothea Lange, Walker Evans—he seems prophetically to have sensed that America was in danger of dying from within, of giving up. Temperament, ideals, and depressing news stories combined to push him to make the best photographs he could of a place where his and the country's hopes coincided.

If the work in *Time in New England* resulted from Strand's need for it, how does the urgency appear in the pictures?

There is, to begin with, his evident compulsion to record what he saw as astonishing light. Everywhere. Strand was

one to whom an unusual sensitivity was given, and there is a striking luminosity in all but his earliest pictures. He seems to have observed a charge running through the world, a current that suggests, without the theology, passages from Gerard Manley Hopkins. The remarkable thing about finding this in the New England pictures is, of course, that we expect there a weakened, even drab illumination. In fact, the photographs are filled with deep grays, but the grays are energized by accompanying blacks, and many of the views contain brilliant if small highlights, especially the close-ups of vegetation and stone. The geography is recognizably ours except that it seems to glow almost in the manner of El Greco.

There are, too, preoccupations in *Time in New England* that are not as consistently apparent in the rest of Strand's work, particularly in that which followed the book—his concern to show specifics and generalities together, and his resolve to present these compounds in formally innovative ways.

Strand, I think, understood that combining the concrete and the universal is at the center of what makes art important (certainly it is what makes it of more value to more people than interior decoration or philosophy). He knew, as William Stafford was later to write, that "all art is local" but is saved from being trivial by its wider applicability. And he must have seen, from the evidence of an "art world" not wholly unlike ours, that there was not much of this alloy around. He was committed to it, nonetheless, because only it was worthy of his subject.

The generalizations—that nature is beautiful if harsh, for example, and that human beings are, though small, potentially honorable—are apparent not only within single pictures but as themes that emerge from the whole series. But if generalizations are in a sense the final reward for our

attention, it is the specifics that are the pleasures. There is, for instance, the wonderful peculiarity that accrues from dilapidation; what we build gets differentiated as it comes apart—boards loosen to crazy angles, windowpanes fall out, and rain and snow streak white clapboards. People too become marked and thus individualized as they age, and Strand's portraits are never better, as a whole, than they are here (he made telling portraits from the start of his career, even as he was otherwise struggling through various early exercises in formalism). The New Englanders are types, but like those of whom Edwin Arlington Robinson wrote (and Newhall includes one of his sketches), they are typically eccentric. Mr. Bennett is every Yankee, but every Yankee is by definition his or her own person, and Mr. Bennett has his little piece of string looped there in his collar. We know these people in part by expressions we judge to be charac-teristic—of alertness or resilience or contentiousness or resignation—but we see these attitudes on unique faces and always together with how the person fixed a tie or chose a print blouse or failed to comb down windblown hair. No one is wholly interchangeable with another. It is in fact the strength of these portraits, coming as they do toward the close of the book (appropriately, since it is roughly chronological) that accounts most for its affirma-tive conclusion. Much modern history ends with elegy, but not here, with Strand's believably living and importantly representative people, citizens as particular as a name on a mailbox and as general as those of whom the Constitution speaks—we, the people.

The second kind of evidence within the New England pictures that suggests Strand's especially acute need for them comes, I think, in the meticulous but daring way he structured them. He took large risks, the kind one does not take unless one has to. When set against the documentary

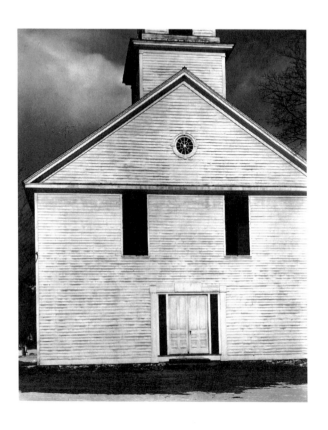

XIX Paul Strand, *Church, Vermont*, 1944

conventions built up in the previous decade by FSA photographers (theirs was a generally four-square approach), Strand's later New England pictures are the sort that, though attracting a diverse audience because of their subject, puzzled many observers on second look. I can imagine him being asked even today why he took pictures *that* way.

Strand had tried some of what he did in *Time in New England* elsewhere, but he never pushed it as far. In the book he worked off axis as if it were a moral principle (in a way it was), but usually just *slightly* off axis; occasionally the vantage point was even chosen in the face of a symmetrical subject, as in the case of a wood stove. He off-centered portraits (Harry Wass, Bertha Moore, Leo Wass, Susan Thompson), but only part of the time for reasons that can be explained in terms of bringing in additional relevant subject matter. And he off-centered symmetrical buildings, occasionally going so far as to frustrate simplistic documentary expectations by shaving away the smallest edge of the subject, as in the view at the end of the book of the Vermont church in 1944 (it is, I think, among the greatest architectural pictures ever made). One comes to wonder if there is anywhere in the volume a picture of a doorway or window in which the subject is distributed equally within the frame; many are close, but only that. Other pictures surrender a significant part of their foreground to what looks to be, by common standards, not the subject: A tree stands, for example, in the way of a perfectly balanced house, and a telephone pole interrupts our view of a symmetrical town hall; any competent amateur with a view camera could have minimized these seeming distractions. Then there is the wild tipping (these were not the days of Garry Winogrand) of a church and town hall, and of an eagle over a doorway (what kind of patriotism is this?!). Not to mention pictures

framed by large quantities of the apparently irrelevant, as with the photograph of the little fragment of a view of birches seen from inside what appears to be a barn. The photographer seems not to have taken the necessary step to get close enough to the opening and for his laziness gotten a picture two-thirds boards (and what a wonderful picture it is . . . I think it changed my life as a photographer). There is, too, the question of why Strand made several of the portraits as horizontals (Mr. Bennett, Beatrice Albee, Louis Cole, Bertha Moore, Belle Crowley), since the human face and figure are by nature perpendicular, and since the character of the walls against which the subjects stand could be established with less space.

Strand was daring even in some of the pictures where he chose orthodox composition. The seascapes, which tend to be conventionally divided into thirds (apparent when one notes divisions within the sky, as opposed to the placement of the horizon), are, however, mostly without centrally placed subjects (the expected ship, bird, or wave), and thus even today scare many viewers into resistance. Paul Metcalf suggests in his introduction to the second edition of *Time in New England* that there was an affinity between Strand and Melville, and the seascapes support his observation, allowing us only the light on clouds and over the ocean's surface as consolation for the anxiety of being left alone in such an expanse. Though the traditional, decorous proportions within the frame induce a calm.

The pictures are, in any case, not predictable, and they succeed. Consider a photograph like the skewed view through an interior door into a parlor in Prospect Harbor, Maine (plate XXI). What could have compelled an artist to look hard enough to bring those fragments into such an unexpected indivisibility? It and other pictures are informed by photographic history, but their maker was, as Rilke said of Cézanne,

XX Paul Strand, *Toward the Sugarhouse, Vermont, 1944*

XXI Paul Strand, *Parlor, Prospect Harbor, Maine*, 1946

"heedless." The New England photographs are the work of a disciplined artist who, in order to share what he valued most, took the risk of being free.

Among the reasons I believe that Strand's finest pictures came from his love for America is that they came less frequently once he left to make his home in France in 1950. Away from the United States, the urgency seemed to fade.

To attribute this decline to his emigration may at first seem inconsistent with the success of his earlier pictures in Quebec and Mexico. Those places, however, were not as distant, his time there was brief, and the scope of his work was relatively narrow. More important, both places were strikingly similar to regions he already knew well in the United States—New England and New Mexico. And in Mexico he worked under official government sponsorship, which presumably reduced the isolation he would otherwise have experienced.

There were, it is true, other factors besides moving to France that probably contributed to the slackening in Strand's achievement. He was approaching old age when he emigrated, and he must have had less strength to work (photography—*taking* pictures—is kinetic). There is as well the fact that he had just finished unquestionably great work; it would be human for him to have felt, even as he probably resisted admitting it to himself, that he had completed what he most needed to do. He appears, as well, to have been unusually happy in his personal life, a condition that seems—alas—to slow many artists down. With his marriage to Hazel Kingsbury in 1951 he gained a particularly sympathetic partner, something one can see in a sweet book published in Italy in 1989 (Paolo Costantini and Luigi Ghirri, *Strand, Luzzara*), which reproduces seventy-one pictures, many informal, that she took while they were there;

they suggest her respect for him and the pleasure and relaxation they found together.

The central explanation, though, for the change in the quality of Strand's work after he moved to Europe is, I think, to be found in his own description of events. When he was asked by an interviewer why he decided to go to France, Strand began by noting that in America, at the time of his departure, "McCarthyism was becoming rife and poisoning the minds of an awful lot of people. Then there arose the question of where do I go from here. The decision finally took shape in a very old idea, that I would make a book about a village, a small place. I liked the idea of being confined to a small place and then having to dig into its smallness. But I did not want to choose a village in America during McCarthy's time, when his ideas were doing very bad things to my fellow countrymen. It isn't that I am disloyal to my country—I had just finished a book on New England. . . ." In France, however, he and a writer friend discovered that "there were many villages, but we didn't know how to go about it. The French have a way of closing up their shutters about seven o'clock at night, and we never saw a soul outside on the street. It was very depressing. We felt excluded from what was going on. . . . The upshot was that we made a book from photographs taken all over the country. . . ."[1]

Inevitably, the results were less than originally hoped. How could he explore the general through the particular when he was so distanced from the particular?—he spoke neither French nor Italian. And how could he, under the circumstances, compose as carefully as he had in New England? In a foreign country it is far from easy to study a scene at length when you know that at any minute someone may appear and ask what you are doing and that you can't answer, and you haven't many references and you don't

know the law. Neither is it easy to find and know the subjects for portraits or comfortable to make such pictures when you cannot apply an anesthesia of small talk. In Europe and Africa Strand simply did not share enough to enjoy the privilege of working from within. As Wallace Stegner has written, you are at home only when you live in a place with "complete participation," a condition remote from Strand's.

There is, as a result, a superficiality in some of the later work. The portraits, for example, become more and more idealized; there are greater numbers of younger people, and when he shows the old he allows fewer of the complicated expressions he recorded in New England. It is instructive as well to compare the pictures he made of famous French personalities with the supple, revealing portraits he had done of American artist friends such as Marsden Hartley, John Marin, and Stieglitz. Malraux looks vaguely as if he had been told to impersonate himself, and others as if they might be captioned "European intellectual" or "European artist."

Strand's drive to compose inventively and with precision also tended to subside (though there are, happily, beautiful exceptions to this generality, like the picture *Water Wheel and Colossi* from Egypt). Off-centering is used less, and when it is it begins to seem formulaic. Tipping is abandoned. And the edges of the pictures become less critical; the all-important slivers of subjects that used to lie at the borders of the frame—the inch more of a door casement at one side than the other, the trees at the extreme edges—are not as often there to lend subtlety and weight. One recalls, too, the many close-ups in *Time in New England* where Strand's construction is so exact that nothing could be altered without losing the whole. Little of this fanatical attention is to be found in work afterwards, except where Strand composed in the manner of Piero della Francesca, an admirable painter

but, to my eye at least, no more enabling for Strand than Cézanne had been for Hartley.

There begin to appear in later work, too, hints of weakness not in evidence before—sentimentality and tendentiousness. His admiration for traditional cultures, which in America had brought him to picture anachronistic but more or less freely accepted lives of hardship, brings him close, when he is abroad, to exalting third-world deprivation, as if it had been embraced in the same relative liberty as his subjects in the United States had adopted their austere ways. Strand's idealism also began, in the absence of an opportunity to embody it in less heavy-handed pictorial strategies, to assume didactic form—views, for example, of new dams and of stalwart figures riding combines, pictures easily overtaken by events, as are some from Romania now.

But this brings us back to the most moving aspect, I think, of Strand's life. He did care, passionately, always. The problem was, as it has been for many Americans, what to do when the United States goes beyond what one can tolerate. Strand's answer was to leave, which is not everyone's, but it deserves respect and compassion. Strand was a thoughtful, informed person who surely understood what exile can mean to an artist. He knew, for example, that Hartley had done major pictures in New Mexico and then had sunk into confusion in Europe. He knew Stieglitz had come home after a time in Europe, apparently convinced that to be an expatriate was to be crippled.

Some kinds of artists seem, it is true, to be relatively unaffected by relocation, but these tend to be the more abstract varieties like composers, architects, and nonrepresentational painters. Others, perhaps the majority, find that they cannot survive as artists out of the context that originally fostered their art. Childhood experiences, for example, which are of critical importance to most artists' work, are of

reduced application abroad. All the years, in fact, that an artist has spent in his or her native country are the basis for important judgments about what is characteristic and lasts; to have the relevance of that framework lessened by moving is a serious handicap. And there is the matter of language; few are able to make a second language fully their own in the way that Conrad and Nabokov managed. The problem is not just of importance to professional writers, but to all artists who think—which is to say, use language—in order to consider their work. Strand was articulate and it must have been vaguely debilitating not to have his English kept sharp against that of others.

Photographers can be especially vulnerable to dislocation. It is not possible for them to carry to a new country, as can writers or even in some cases painters, the fundamental ingredient of their particular art—the surface of life. A photographer is impelled first by a love of the appearance of things, and this affectionate interest in outer fact cannot always be quickly rekindled in a new place. One thinks of Kertész, for instance, many of whose European pictures express such open delight, but who never found when he left, on the evidence of the pictures, a way equally to love us here.

Time in New England was the summation of one person's efforts to bring his nation back to the best in itself. When he left it was, among other things, an admission that he suspected it could not be done, and his departure still has the power to test those of us who have stayed. By what right do we compromise and stay?

Strand's own motives were presumably mixed, as are all human inclinations. There are those who think it likely that Strand, because of long-held radical convictions, may have had reason to fear what might be in store for him if he

remained. On the other hand, there is no evidence in his life that he was a coward, and it does not seem unreasonable to credit him with leaving at least in part on the basis of his respect for the American ideal and his desire not to compromise it. In fact his devotion sometimes seems to me almost as worn and self-searching as the expression on Mr. Bennett's face. Strand knew, I think, though he did not often allude to it or perhaps even consistently confront it (what would have been the use?), that leaving was a kind of death. But the alternative was worse—a betrayal of principle. Had he been one to see life as tragic, he might have come to a different conclusion about what he ought to do, but he was by conviction an idealist.

To whatever extent his going was also an act of despair— inevitably it was this too—it calls into question the affirmation he made in the New England pictures. But the photographs have now, as they deserve, a life of their own. What artist has not, after all, seen more deeply and patiently than he or she has lived? Cézanne's erratic behavior was the reverse of the geometric stability he painted, and Rembrandt's lavish personal taste was in ironic relation to the humble ways of most of the people he so affectionately depicted from the Bible. A saint's gift to us is a life, but an artist's is mainly a vision. Though Strand's life and art were sufficiently congruent, it seems to me, to deserve respect.

1. Paul Hill and Thomas Cooper, *Dialogue With Photography* (New York: Farrar, Straus & Giroux, 1979), 7.

LAURA GILPIN

IN THE EARLY 1950s the way through Monument Valley was by a dirt road that was haphazardly marked and in places drifted with sand. My parents were innocent of how far this went on until it was too late to turn back, and our family, recently out from Wisconsin, saw a West that remains for me an ideal—a landscape and a people in relative harmony.

Laura Gilpin: An Enduring Grace has reminded me of how much I depend on some of her pictures of the Southwest. I can admit that the work is, judged solely as photography (but is this possible?), perhaps minor, without losing the point that she recorded certain truths about her subjects better than anyone else had, and in so doing made pictures that continue to encourage us.

Gilpin's achievement is mainly, I think, with two groups of photographs. The most important are her sharp-focus portraits (both close-ups and views that include some background) of Navaho women and children. Dorothea Lange,

This review of *Laura Gilpin: An Enduring Grace* (Amon Carter Museum, 1986), and of the exhibit of the same name, has been revised from its original form in *Aperture* No. 110, Spring 1988.

XXII Laura Gilpin, *Rabbit Ears Pass, Colorado*, 1937

who respected Gilpin's work, must have admired these especially; they document human dignity, gentleness, and courage.

The other pictures that Gilpin did particularly well, and in this case right from the beginning, were distant landscapes. All her books have contextual shots that can stand by themselves as important records of the geography's light and shape. At their best these views are calm; whether in soft or sharp focus they are "straight" in a way that gives that word its full meaning, just as Strand's contextual scenes often do.

Beyond this, Gilpin was a versatile professional who remained open to what she met, and so can surprise us. Some of the color pictures that appear in *The Enduring Navaho* (1968), for example, are of unusual beauty. She used in them the inaccurate response of the film at that time to achieve a degree of abstraction, but she also suggested by the film's tendency to pastels a quietness that she saw in her subjects. It was a creative use of a technical limitation.

Above all, though, it was the affection with which Gilpin approached her subjects that yielded riches. There is in *The Enduring Navaho* a color view of women drying peaches in Canyon del Muerto, for instance, that is eloquent about Providence. I wish it had been included in the new book, as is an autochrome (1912) of peaches in a bowl; both pictures amplify the conversion experience Gilpin had at the beginning of her acquaintance with the Navaho when she was handed, while lost one day in the Four Corners area, "three cool, delicious peaches" by an Indian who spoke no English. There is, too, in *The Enduring Navaho* a color shot of women making fry bread—a split second of ease and order and joy that exactly cross-references the best of art and life.

Laura Gilpin: An Enduring Grace and the accompanying show have, despite some omissions, many virtues. The exhibit, which I saw in Denver where it had been handsomely installed

by Eric Paddock, encourages a contemplative response. And the thirty-minute tape that is screened as part of the exhibit is a model of unpretentiousness (there is a wonderful, slightly daffy sequence in which Gilpin and Beaumont Newhall make platinum prints, in what appear to be rustic circumstances, while Nick Nixon, then a student at the University of New Mexico, stands by as audience). The book, which was designed by Eleanor Caponigro and printed by Meriden-Stinehour, is produced to high standards, and Martha Sandweiss's writing is clear and polished.

Among the most welcome virtues of the book is Sandweiss's tact. She describes the outward signs of the friendship that Gilpin shared for over fifty years with the nurse Elizabeth Forster, but Sandweiss does not speculate about it. She sees that what was important, beyond the fact that the friendship helped Gilpin's work with the Navaho, was the degree of loyalty Gilpin and Forster showed each other, a patience unusual in any relationship. If we are curious about more, by what right do we inquire? By reference to the supposed public good that comes from making everything always known? It is a dubious claim. Gilpin's own standards were those of a self-respecting, private person, and it is natural that one who likes her, as Sandweiss does, should in most cases accept those standards.

Sandweiss is correct, indeed, usually to let most of Gilpin's experiences speak for themselves; Gilpin's life was difficult, and events in it make for painful enough reading without expanding on them. She was often compelled, for example, to waste time and energy in order to earn money. She accepted a darkroom assignment when she was nearly fifty, for instance, that called for her to duplicate in multiple copies, on hand-coated platinum paper, a wealthy family's photo album; she had to make a total of 1,668 prints, and she worked at it for ten hours a day until she was forced to

wear a respirator and goggles to limit an allergic reaction brought on by the chemicals. In the telling of which things Sandweiss customarily notes little about Gilpin's thoughts except that Gilpin was relieved to get the pay. The fact that she was not broken in spirit is apparent, and Sandweiss's restraint effectively evokes Gilpin's stoicism.

Why is Gilpin not more widely respected beyond the Southwest? The question arises in part because the book is not, despite its strengths, exactly what would best have brought Gilpin's importance to the attention of a wider audience.

The focus of *Laura Gilpin: An Enduring Grace* is biographical, and it was apparently decided that the biographical task could be performed relatively free from the critical one. So instead of using the large format and fine printing of the book to show us, more adequately than Gilpin's original and sometimes coarsely printed books did, as many as possible of the best portraits and landscapes, Sandweiss devotes a substantial number of large plates to comparatively undistinguished pictures, among them photographs Gilpin made during school days and later of clients, and of staged scenes in the pueblos that Gilpin herself eventually regretted contriving. Conversely, numerous strong pictures have been omitted, or in some instances reproduced in small size as illustrations that appear with the text. The overall effect is to give the reader biographical information about a life that does not seem, as much as it might, to merit our attention.

This result is the more unfortunate because had emphasis been placed on the best pictures the book would better have proven what Sandweiss correctly says in the text—that Gilpin's photographic concern with the Navaho was deeply personal. The best pictures show, as they capture

the Navaho's respect for craft and the land and for life's wholeness, the intensity of Gilpin's own commitment to these same values.

Even if the new book and show do not make the strongest case for Gilpin's accomplishment, why at this point, seven years after her long life, does the case remain to be made?

It has frequently been noted that she was the only serious landscapist (excepting, it seems to me one must add, Lange) of her generation who was a woman. Is it not therefore certain that she faced special handicaps in her work, and that these might account for whatever weaknesses there may be in it? And is it not possible that her photography even now faces unjustified resistance?

With regard to current prejudice against her pictures I can only say that I have not encountered evidence of it that I am able to recognize (to argue for the rightness of values different from hers is not in itself to be prejudiced against her as a woman). As to whether she had a more difficult time as a landscapist because she was a woman, I'm positive that she did. Just to be forced, for example, to be more concerned with one's safety would be a serious additional burden while photographing.

The extent to which Gilpin was handicapped by prejudice is hard to know. She herself was good-naturedly dismissive when asked about it, and Sandweiss is cautious about claiming it, perhaps because so many of Gilpin's best portraits depended on access and trust that were afforded precisely because she was a woman.

In any event, arguing prejudice does not establish the existence of significant art. Gilpin's pictures do that, and return us to the puzzle of their neglect.

It seems to me there are two standards, neither of them

XXIII Laura Gilpin, *Florence at Long Salt Hogan*, 1953

simple or absolute, by which Gilpin's achievement has been judged modest.

The first is the extent to which her pictures are and are not new. As with all art, it is an issue to be decided in terms of the way the art operates (technique) and what the art says (content), but these factors are inextricably bound, and never in exactly the same way in any two pictures, so that rules are out of the question. We do generally agree, however, that being first has some importance, and that though freshness can be relatively more or less a matter of technique or content, a work of art is less strong when its freshness is wholly one or the other.

Gilpin's pictures, even the finest of them, employ styles that had been tried before. What finally distinguishes her best photographs is the sympathy of her vision. She seems to have loved her subjects more—you can see it in the way the people respond—and as she teaches us that love, the subjects are new to us. It was not a breakthrough on which other photographers, specifically, could build, but one by which each of us can learn a warmer response to life.

The second criticism made of Gilpin is that she was sometimes untruthful about the mixed, imperfect world. She was for a long time associated with what is to many a suspect persuasion in photography—pictorialism, a school that adopted rather painterly means toward idealistic ends. She was trained under Clarence White, a leading practitioner, and for years relied on pictorialism's characteristic soft-focus lenses, and composed in the emphatically simplifying manner of her teacher. The results were not on the whole as convincing as in later photographs when she used a less manipulative approach, though some of her pictorial work is lovely, especially the views of the prairie, the Four Corners, and the Garden of the Gods.

There is nothing inherently wrong with pictorialism and

its assumptions, as is established by the vast achievement of Edward Curtis, whose work is in varying degrees part of that school; his attainment is, I think, as important as that of seemingly straight photographers like Ansel Adams. Curtis was, though not a documentarian in the generally accepted sense, a seminal creator (director?) of scenes that define, by the power of his imagination and insight and graphic skill, an unforgettable conception of the West. Just as Clarence White created an imaginary East, and Doris Ulmann a South, so Curtis created a West, though the scope of his success is without parallel. There are at least twenty-five Curtis views that are, once seen, as indelible as any description by Willa Cather or visualization by John Ford—for instance, Curtis's riders in Canyon de Chelly, the weaver by the cottonwood root, the Hopi girls on the rooftop, the women at the Acoma well, the view of the feast day at Acoma, the Piegan encampment on the plains, the Kwakiutl house frame . . . and many portraits. To which one can add that there are hundreds of other Curtis pictures that effectively amplify these.

Curtis is important to a discussion of Gilpin, who often recalled seeing over her father's desk a print of the riders in Canyon de Chelly, because she not only admired his work but struggled to match it, or failing that, circumvent it. Her effort went on fitfully for a long time (as can be seen in views like the one she did in 1939 of women at the Acoma well, a weak if sharp-focus homage to the Curtis view of the same subject, and a picture she thought successful enough to use as the frontispiece for her book in 1941 about the pueblos).

A common problem with pictorialism is excess—abstracting so far from the particular that the scene is of everywhere and nowhere, and thus is boring, worth just a glance. Gilpin sometimes fell into this mire of the generic, especially in her early work around the pueblos, and it is a measure of her

determination effectively to share her subject with us that she kept experimenting until she found a way out. Lacking anything like the imaginative gift of Curtis, she reached some of the same truths by concentrating instead on a particular tribe, and by adopting a style—the sharp-focus documentary one—that allowed individuals a specificity so compelling that it paradoxically made them universal.

In giving up the pictorialist style Gilpin rarely abandoned, however, the idealistic assumptions that underlay it; usually she photographed so that people and the land looked their best (anyone who had walked through Gallup, New Mexico, knew for instance that she had excluded from her portrait of the Navaho the affliction of alcoholism).

For a time this bothered me because I felt that photography ought to start with and remain faithful to the appearance of the world, and in so doing record contradictions. The greatest pictures would then—I still believe this—find wholeness in the torn world.

Is there anything, though, that is wrong with a different emphasis—picturing, without fully acknowledging the disturbed surface, an ideal? Photography is less manipulatable than painting, but it does have the capacity to change what we see away from the literal, and many fine pictures have in fact depended upon removing us some from the actual surface of things. In Frederick Evans's grand forests, for example, there is not much jumbled and scratchy brush (as around his cathedrals there is not much discordant industrial society); behind Clarence White's beautiful women there is little of the clutter that we know in real homes. The photographers used their craft to suppress warring detail, and by this distortion of the literal world expressed a faith in a less literal one; the views to which they testified were contradicted by a majority of evidence, but supported by the quality of exceptions. And we are thankful for their work

because, as the poet J. V. Cunningham has written, "Simplicity assuages / With grace the damaged heart."

At a time when, more than ever before, we have to live by hope, the question is what photography can contribute. If it can take us by way of the ominous surface of life to discoveries that can save us, this still seems to me the best, because the surface is where we have to live most of the time. Alternatively, if some art can allow us briefly to escape that surface so that we recover a memory or an intuition of what is affirmable, that contributes too.

Kerstin and I have in our home, among a variety of pictures, three Curtis gravures. We rely on them even though they are not the most complexly accurate photographs of which we know. Such photographs would probably be, for us, Atget's late views at Saint-Cloud and Sceaux, but even if we could afford to own them in the original I'm not sure we would have the energy of spirit to live in company with Atget's sadness, however relieved it is by a sense of glory.

Some art is meant, I think, to help us as we rest, as we get ready to go out again. Laura Gilpin's pictures are of this kind. One opens books of them in anticipation of renewal.

XXIV Judith Joy Ross, *Eurana Park, Weatherly, Pennsylvania,* 1982

JUDITH JOY ROSS

JUDITH JOY ROSS has, as an artist, no formula. She starts over again each time—the riskiest way to do it.

She has a style, of course, but it is austere. It cannot, if she panics, be used to take the place of content.

Photographer Diane Arbus said that when she stood in front of her subject she wanted to accept it as it was. "Instead of arranging it," she said, "I arrange myself." Ross's approach is like that, except that occasionally, on the evidence of the peace in some of Ross's photographs, she may enjoy an even wider freedom—to arrange neither the subject nor herself.

Ross's work is beautiful in its transparency. It reminds me of lines by Keizen, translated by W. S. Merwin:

The water is clear all the way down.
Nothing ever polished it. That is the way it is.

Ross's method promotes this clarity: She uses a view camera, which because of its size makes openness necessary in dealing with people, and she prints by contact, which results in the subtlest possible rendition of a negative.

What is it that we see, free from distortion? In spite of the smiles on many of the children's faces, we understand

from her pictures that the nature of life is suffering. The children are beginning to sense how exposed they are, and to feel the pain in that.

They only know their condition a little, however. It is the photographer who knows it enough to discover the picture. Just as one recognizes innocence only after losing it, so one understands vulnerability best after experiencing it.

The photographs are a record of compassion, of shared suffering. We observe it in the sympathetic identification that brings Ross to her work, and in the children's tentative smiles, their brave impulse to trust her, to sense themselves in her.

It is a bond that, by its nature, even includes us. We take hope from it.

This statement accompanied pictures by Judith Joy Ross in the book *Photographs from the Real World*, edited by Dag Alveng (De norske Bokklubbene, 1994), a catalog of the group exhibition by that name at the Lillehammer Art Museum in Lillehammer, Norway, in 1993-1994.

SUSAN MEISELAS

SUSAN MEISELAS'S picture of the shadows of bus passengers being searched by the Salvadoran military (plate XXV) makes me afraid both for the passengers and for her. I don't think she wanted us to fear for her—I saw her once in a public interview and she was absolutely self-effacing—but in order to show the passengers' danger she shared it. Only by standing with them and partly turning her back on the soldiers, by accepting that risk, could she make us feel what was happening. She records it so well that we can almost hear sounds—the chambering of ammunition, the crying of a baby.

Even though I know that Meiselas survived the incident, I also know from the bravery it took to make the picture that she would probably do it again, and that things might end differently. It was unpredictable when one of Somoza's soldiers killed television correspondent Bill Stewart as he knelt in the street in Managua, Nicaragua.

The setting of Meiselas's picture, which suggests a mass grave, seems to be a cut by the side of the road, a ditch. We have looked at many such places. I remember watching on

the news in the 1960s a report about a patrol that captured a man along a road during an African civil war. As the soldiers interrogated their prisoner he realized that they were going to kill him; he implored their mercy, weeping, stumbling into a ditch, pleading, until an officer put an end to him with a machine gun. "If you have no imagination," Celine wrote, "death is nothing. If you do it is too much." Watching this person die, for whom it had been too much, was one of a number of filmed murders that helped awaken my imagination.

I hate my country's part in most third-world politics, but to keep that abhorrence alive—it is almost the only virtue I have in the matter—I seem to have to be shown the problem again and again. I depend on others' courage. I am saved in a different way from the people on the bus, who may literally owe their lives to Meiselas's presence, but I owe her my caring.

There are many contexts in which it is embarrassing to say one is a photographer, but with the example of Meiselas's witness it is too easy.

The word "artist" is, on the other hand, not at all tempting to use about oneself in the presence of her photograph. Her goal seems not to have been art, with its eventual calm, but reporting that would move us. What pictures have artists made that deserve as wide an audience as does hers? There are some, but an economically perfumed aestheticism that has dominated the visual arts in the United States since World War II has resulted mostly in pictures that are, when set against the facts in Meiselas's photograph, irrelevant.

The shadows in the picture are long. Is it morning or late afternoon?

XXV Susan Meiselas, *Soldiers Searching Bus Passengers,*
Northern Highway, 1980

XXVI Michael Schmidt, *Berlin-Kreuzberg*, 1982

MICHAEL SCHMIDT

Berlin-Kreuzberg: Stadtbilder opens with a photograph of three people looking at the city through a break in a wall of trees. Thereafter there recur, as leitmotifs, views of parks and of walls (including the wall that surrounds all of West Berlin), bringing us to ask whether we live in a garden or a prison. It appears, on the evidence of this anguished and humane volume, that we have not so much been expelled from Eden as condemned to remain in its ruin, our hope now being with gardeners of sufficient gentleness, commitment, and imagination.

Though the people shown are Berliners, they look like most of the rest of us throughout Europe and America—withdrawn and quiet, in search of a minimum of dignity and perhaps even happiness. Adolescents occasionally enjoy a brief grace that Michael Schmidt records as radiant—a young man laughs good-naturedly, a teenage girl smiles, and children play in the sun. A few of the of the elderly smile too.

This review of Michael Schmidt's book *Berlin-Kreuzberg: Stadtbilder* (Publica, 1984), which has been revised for clarity, was originally published in a German translation in *Camera Austria* No. 14, 1984.

Each is tested by the landscape, which is synopsized by close-ups of bushes and tree trunks growing out of worn, compacted clay in cement-bordered plots; originally conceived as places of green ornament, these locations are now dry and scattered with waste. Much of the city appears to be undergoing repair, but the conception of most of the building is so lifeless—decoration at most entryways is, for example, just a number—that we understand little will change.

Schmidt's pictures of this landscape acknowledge the logic in giving up, even perhaps in hastening the end of such a place. It is a pull toward darkness recorded near the end of the book with a pair of pictures of young men at night, one with his face mostly obscured, and with a bare, muscular arm extended threateningly. The other person, slouched on a bench, is apparently drunk.

Schmidt concludes his book, nonetheless, with a substantially different pair of portraits, these of young men who are alert and not unkind in appearance. Neither looks fully capable yet of withstanding the ordeal of the city in which he must live, but each offers reason for us to care and to hope. In them Schmidt gives us a brave gift, knowing I'm sure that it is more fashionable to catalog failure.

Among the encouraging things about the appearance of new, successful documentary photography is the promise that it gives of more such work to follow. This is so because, as Goethe observed about poets, "a subjective nature has soon talked out his little internal material, and is at last ruined by mannerism," whereas a more objective nature "is inexhaustible, and can always be new," taking as it does for inspiration and consolation the whole world beyond the private one.

In what sense, however, is documentary photography objective? How can one call a book of seventy-four pictures

of West Berlin objective when three of the pictures are of the same girl in the same rocking chair, and another is of a cigarette machine?

Admittedly, all photography is to a degree subjective, even that produced by an automatic camera in a bank; it results from a human choice to make the photograph *there*. An infinite number of pictures could have been taken in Schmidt's area of Berlin, and we know something about Schmidt as an individual when we see what he selects— which fragments of life he believes worth the trouble to show us. And of course he is interpretive when he organizes his book—when he combines in one spread, for example, a view from the street into the window of a murky room, and a view on the street of the open, dark end of a moving van, suggesting how dismal transience is.

We also know something about Michael Schmidt, however, from the way he has often allowed the subjects just to be themselves. Having chosen a subject—a specific tree or child or street—he regularly adopts in front of it a manner of approach that is, while not neutral, unobtrusive.

When we think of pictures in the documentary style we think of views that tend to be frontal, that are made from enough distance to put the subject in context but not so far away as to reduce the scene to an abstraction of oriental planes, and pictures that are printed so that they are not difficult to retranslate back into life. There are, to be sure, as many varieties and degrees of this style as there are photographers who use it, but its distinguishing characteristic is always the same, restraint—an avoidance of bizarre camera angles, extreme lenses and formats, and exotic darkroom manipulations. The rationale is respect, a deference for the subject on its own terms, a deference afforded naturally to what is itself eloquent. The photographer's chief effort is to be fair.

As I write these observations, and note on the book jacket a photograph of the thirty-nine-year-old photographer, I am reminded that the basis for work of this quality is not only a gift for doing it, but years. The balancing of subjective and objective vision assumes enough time to come to conclusions about oneself, the world, and their right relation.

On the front of the jacket and repeated within the book is a picture of a young woman holding a child (plate XXVI). The two are shown by themselves in a park. The disposition of the woman's body gives the composition a vaguely centrifugal character, made the more unsettling by her location slightly off center in the frame, and by the fact that her attention is focused apprehensively on something outside our view. She embraces the baby protectively. We note that the landscape where they try to rest is the one we all know, one that is not without beauty—in this case, dappled light— but that is also exposed, dirty, and heavy with random threat. How different the scene is from the traditional one, from representations by Tiepolo, for example, of rest on the flight into Egypt; here there is no Joseph, there are no angels, and there are no arching palms. Flight itself is all but impossible. As careful viewers we pray for the two, in our ways, as it seems to me Michael Schmidt does in the pages of this remarkable book.

ANSEL ADAMS

ANSEL ADAMS reminds us in his autobiography of how disparate were the elements of his life. He photographed not only the glories of Yosemite but, as a commercial photographer, raisin bread, glassware, and everything else that promised a living (he enjoyed a large income only at the end of his career). His landscape work eventually sold millions of books, but appeared at one time on coffee cans too. He spoke publicly for conservation, but also on TV for Datsun. Though a man of great presence and dignity, he relished directing corny amateur theatricals. He hated the crowding of national parks, but had bumptiously led group hikes in them. And though he devoted an amazing part of his time and income to helping others, he enjoyed driving a white Cadillac with a special license plate and a horn that played seventy-two different tunes. As he protested not long before his death, "I'm no plastic Jesus," and he wasn't. Like many of his generation, for example, he seems never

A review of Ansel Adams: An Autobiography (Little, Brown, & Co., 1985), here revised for clarity, published first in The Times Literary Supplement (London), May 16, 1986.

really to have faced what his country's economic system meant for the land.

The autobiography makes clear, however, something more remarkable than the disparities and contradictions—he believed, with proper modesty, that the different aspects of his life had come to a kind of whole. It is perhaps not surprising that he did, since as an artist and an ecologist he found unity in what at first seemed only diverse; when he photographed a landscape, no matter how intricate, he stressed its coherence, and by implication, the relatedness underlying nature.

In part he believed that the wholeness of his life—a life itself included in nature—had been a gift. He tells of three instances, in a final chapter called "Harmony," when his life was inexplicably spared. With such mysteries in mind he writes that "I have often had a retrospective vision where everything in my past life seems to fall with significance into logical sequence."

He also believed, however, that some of the shape in our lives is of our own making, the result of our efforts to conform to principles. His father, whom he deeply loved, "considered a profession an obligation to be practiced well and passed on to others through teaching and example," and Ansel Adams worked to do this, helping to found the department of photography at the Museum of Modern Art, the photographic magazine *Aperture*, and the national organization The Friends of Photography. It is apparent from these and other generosities that he wanted to match his private and public conduct with the harmony he saw in nature and recorded in his art. Adams was in many ways a romantic, but he never thought an artist was or ought to be separate from society. I suspect there were times when he would have agreed with Kierkegaard that to be an artist is to have your life stand as a satire on your art, but Adams tried his best to make them congruent.

There were conflicts of time and energy, of course, between being an artist and a public activist for conservation, and the book recounts the sense he occasionally had of the cost to his art of his conservation work. The problem was, at root, that though the two roles looked the same, they weren't; making successful photographs of nature accomplished little directly to save it. Art is not didactic, as he knew ("I never intentionally made a creative photograph that related directly to an environmental issue"), and his greatest pictures, though thrilling, ultimately induced tranquillity—not a useful emotion to reformers.

Despite the necessity for Adams of pursuing several different activities, there was a unifying force behind his entire life. As Auden observed of Wordsworth—that he "early in life had an intense series of experiences about inanimate nature, which he spent the rest of his poetical life trying to describe"—so it can be said of Adams and the experiences he had as a young man in the Sierra. The importance of those early encounters with nature is remembered and reconstructed in a lifetime of photography, and cited again and again in his promotion of conservation. And it troubles us, because his was a passion beyond what we can feel now for places like the national parks, even though they look quite the same; his feeling for such reserves originated in the assumption of vast, undamaged spaces around the parks, without which the parks seem almost trivial, a collection of eccentricities rather than emblems of a land.

There was a unity in most of Adams's artistic practice too. Though he began in the soft-focus, pictorial mode, by the time he decided to be a professional photographer (he spent his early years studying piano) he was close to having developed the style that remained his for the majority of his life—one employing sharp focus and a long tonal range of grays (photographs in the book, which were edited after

his death, include some early and late views that employ an uncharacteristically short scale of grays, reminding us of how consciously stylized were the best known of his pictures). "My vision established its own groove, as I know I have been derivative of myself for fifty years," Adams writes.

Constancy of motivation and practice must surely have helped Adams focus his energies and achieve his vision. Landscape photography is a rigorous calling, not only physically—the equipment is heavy, and there is a lot of ground to cover—but as it requires an alert, even tense patience. Few landscape photographers have, working within these demands, been inclined to radical shifts of subject or craft.

Constancy amounts to a problem, however, in the writing of an autobiography. The center of the life with which we are concerned here—Adams's art—is in important ways static, and thus not easily kept interesting. There are in the book many anecdotes—I enjoyed them—and statements on aesthetics, but our understanding of Adams's accomplishment doesn't change much once he finishes describing his early life. This may be why Adams found it, as he admits, difficult to begin writing—there was little fundamental that he hadn't said before. And so, with nothing pressing, the book occasionally resembles, at its weakest, a list of acknowledgments, genuinely felt, but private.

The price paid for believing one's life to be whole is a tendency to suppress inconsistencies. As the gentleman he was, Adams does not discuss many personal matters, but even outside that constraint he avoids most trouble. He does mention some conflicts—with James Watt, David Brower, and others—but he lets us see few conflicts within himself. There are hints of a darker side in his adult life (moderately heavy drinking, for one), though little is unambiguously acknowledged. Only once, for example, does he directly mention the charge, common throughout the photographic

community, that his "photography [is] not relevant in today's world." There is an important defense to be lodged against that attack, as well perhaps as a qualified admission to be made (on the evidence of some pictures he occasionally attempted of the urban/suburban world, pictures that weren't very successful), but the only response he offers in the book—that "it is just as important to bring people the evidence of the beauty of the world of nature and of man as it is to give them a document of ugliness, squalor, and despair"—is not nearly enough. It is as though he felt his life should appear as simple and effortless as does his art, and thus that controversies and doubts should be forgotten. But the sense of forced affirmation is sometimes uncomfortably evident. For instance, when he discusses his commercial photography, which he had to practice at a cruelly burdensome rate clear into his seventies, he insists it did no damage: "I learned greatly from commercial photography and in no way resent the time and effort devoted to it." Unless he needed it as diversion—which if he did, suggests other problems—the sentiment is unconvincing and thus disappointing. If you believe, as I do, that art—even beautiful pictures of inherently beautiful subjects—is motivated to some extent by pain, then his reluctance to be candid about professional problems means that the book cannot be fully helpful in accounting for the art.

There are, however, many reasons to value the book. It is excellently illustrated and printed, and gracefully written. And Adams's opposition to the destruction of the environment is inspiring. It strengthened in proportion to the growth of the problem, which is not true of most of us, and his exemplary caring helps us get started again. He wasn't right on everything—he had a tendency to believe one always had to pick the lesser of the grossest evils, and so found himself supporting nuclear power—but his intentions were the best.

He enjoyed himself too, as he emphasizes convincingly many times. The joy was, I think, his serious reason for writing, and one blesses him, in Samuel Johnson's phrase, for his "willingness to be pleased." Adams quotes a friend whose sentiment he obviously shared: "The two most beautiful sounds in the world are the opening and closing click of the camera shutter."

In the end, though, the central value of the book seems to me likely to be its reminder of the outlook that made possible his achievement—his belief that life was to be understood and lived constructively as a coherent whole. It is a conviction that limits the autobiography, but better a good life than a completely successful book.

DOROTHEA LANGE

IN RECENT YEARS there have been several biographies of photographers (Stieglitz, Weston, Lange) that did not teach us much because the authors did not feel it necessary to discuss at length their subjects' pictures, but instead concentrated on a mire of personal failures—pettinesses, self-deceptions, hardnesses of heart—from which artists suffer along with everyone else, but above which they occasionally rise in the practice of their art. Paul Strand described the sort of biography photographers understandably want: "Your photography is a record of your living," he said. *Dorothea Lange: Photographs of a Lifetime* is that sort of welcome corrective to gossip. It reproduces well and in ample size the majority of Lange's best pictures from throughout her career, and then augments them with an essay by the psychiatrist and writer Robert Coles.

Coles presents both an outline of Lange's life and a meditation on her efforts to be truthful about her subjects;

A review of *Dorothea Lange: Photographs of a Lifetime* (Aperture, 1984), here revised for clarity, first published in *The Times Literary Supplement* (London), April 6, 1984.

he himself has studied similar people in the American South, and knows about the difficulties. He respectfully acknowledges the force of her achievement: "She made us look at them, look into their faces." The text is enriched, too, by the editors' decision to include, mixed with the pictures, Lange's own memories of how she worked, and for what; no photographer has been more articulate about the complexities surrounding the word "documentary."

Coles, a compassionate social scientist, is troubled by photography as art. He writes uneasily about style, for example, as if it were vaguely in the way, rather than, as it is to artists, necessary; he worries about balancing subjectivity and objectivity, though the dichotomy is not often on the minds of artists (Lange would have been likely to have said, I think, that she was after an objective vision of truths that cannot be discovered by scientific observation); Coles is concerned, too, about photographers exploiting their subjects, though artists have often had to do this in some measure—we don't condemn Rembrandt for taking advantage of the poor.

There is no doubt that Lange understood part of her job in the 1930s, when she worked for the Farm Security Administration with her economist husband, Paul Taylor, to be the recording of a specific historical crisis. There is, however, also no question that her ultimate goal was art, specifics made universal. She shied away from the word *art*, because the term is in part evaluative, but in 1939 she fought Roy Stryker, the head of photography at the FSA, for the right to have her pictures hung at the Museum of Modern Art. "A documentary photograph is not a factual photograph per se," she observed. "It is a photograph which carries the full meaning of the episode."

As an artist, her prime subjects were, judging from the book, two—the beauty of the world, and the courage it takes

to survive in it. Of the first she was an advocate from her earliest days as a portraitist, and she evolved into a loving observer of human stance, of the architecture of the body at work and at rest. She was also an exceptional landscapist; though she almost never photographed wilderness, she evidenced an enjoyment of natural light and geographic scale, as part of her pictures, that was no less intense than that of her friend Ansel Adams.

Lange's sensitivity to natural light registered, of course, something beyond loveliness; James Agee referred to the quality as "the cruel radiance of what is," and it forms a part of the context for Lange's other subject, fortitude. "I many times encountered courage," she said. "I have learned to recognize it when I see it." The bravery she was concerned to picture was usually set against the most common ordeal—tiredness, having to last. It is perhaps an especially American subject, endurance being one of the few glories open to many in a country where freedom is more valued than justice.

Dorothea Lange suggests ways and reasons Lange succeeded as an artist. Visually, for instance, we note that a majority of her best pictures do not stress so-called photographic vision, that is, composition relying on what may seem arbitrary or accidental cropping, composition where fragments of important subjects sometimes lie off at the edge; instead her finest pictures seem usually to be of whole things. And thus seductively to approximate normal vision. It is as if Lange's gift was to discover artifacts and people that were already perfectly revelatory, rather than to create them by special framing. The beauty of her subjects seems to come from within them, and we are moved by her readiness to be anonymous before it.

From Coles's essay we learn that a part of what brought her to look so long and successfully into others' faces must have been her own suffering. She was crippled by polio as

a girl, was subject to serious illness throughout her life, and was tormented by her need to balance her responsibility to her children (by an early, unsuccessful marriage) with her extraordinary gifts as a photographer. One senses that she undertook work with the disadvantaged because she had experienced, in degree if not always in kind, their pain. Without such knowing, sympathetic identification it is hard to imagine anyone retracing, tired, on a hunch, twenty miles of rainy highway to search out, in a tent in a muddy field, the person who would become the subject of the picture *Migrant Mother*.

Women have occupied almost from the beginning a major place in the history of photography, and it is one of the strengths of this book that it accepts that as a fact, and treats Lange as a gifted human being rather than, exclusively, a gifted woman. She endured difficulties specific to women, but she benefited from being a woman too, and Lange, who had a subtle and probing mind, acknowledged it. While working for the FSA, for instance, she discovered that she was able to win the confidence of her subjects in part because she was female. And she noted that her last years of independent work were possible because, as she jokingly said, she was "kept" by her husband. The evidence is, as Coles cites it, that they held each other in such affection and respect that to be kept was to be set free. In this sense, among others, Strand was right—her photographs were a record of her living.

EUGÈNE ATGET

JOHN SZARKOWSKI and Maria Morris Hambourg have given us in *The Work of Atget* the best criticism we have of an individual photographer; it confirms our need of Atget's pictures—of the knowledge and solace they offer.

Modern Times, the concluding book in the study, reproduces views of "ordinary contemporary things." While the elements in the photographs inevitably do not add up to the texture of life as we know it now, some are prophetic—cramped houses, seductive shop windows, weirdly intrusive cars, and out-of-scale industrial silhouettes on the horizon. Even in these "modern" views, however, Atget includes consolations that he noted in the antique landscapes at Saint-Cloud and Sceaux: Vines are beginning to grow on even the most ephemeral shacks, and light floods the streets. There may be for Atget no more progress in life than is implied in his photographs of a carousel mounted with human figures,

Adapted from a review of *The Work of Atget*, *Volume Four: Modern Times* (Museum of Modern Art, New York, 1985) by John Szarkowski and Maria Morris Hambourg; the review appeared in *The Times Literary Supplement* (London), August 2, 1985.

but he nonetheless remains a lover of returning things: He begins work at sunrise, he is forever interested in flowers and trees, and he studies the work of past generations, especially as their creations evidence a harmony with the world around them (such evidence can be as small a gesture as a well-laid paving stone). Successive generations of people will be nourished to life, Atget apparently believes, by attention to the continuities of nature and culture—proof that modern times are never wholly new and thus never wholly lost.

With the completion of this study it is appropriate to ask two questions: Why does Atget hold the important position he does in the history of photography, and why is this examination of his work so successful? In his introduction to *Modern Times* Szarkowski addresses the first, tracing not only the opinions of other critics but the debts to Atget acknowledged by photographers including Berenice Abbott, Walker Evans, Bill Brandt, Ansel Adams, and Lee Friedlander. In the process of this résumé Szarkowski notes the qualities in Atget's work that most impress him too, qualities that when taken together, and when discussed later in terms of specific pictures, come to a newly convincing explanation of Atget's significance.

The photographs are, Szarkowski demonstrates, "elastic" but poised, focusing on "unconsidered details" and "the chance encounters of things," but showing finally "a new kind of order within chaos." He admires both Atget's intense, relatively straightforward attention to the physical beauty of the world—both its shapes, often revealed in freshly seen juxtapositions that have a unity notwithstanding, and the light that discloses these forms—and his reluctance to assign large meanings to his subjects. Atget's pictures are thus recognized as a supreme expression of most photographers' instinctive faith—a belief in the significance of specific scenes,

a significance fittingly matched to the unique power of the camera for precise transcription—and a hesitancy to theorize, a disinclination encouraged by the resistance offered from such fully recorded specificity.

Szarkowski's reading of Atget's achievement is summarized by the picture (plate XXVII) he chooses to place on the cover and to repeat as the last plate (and about which he withholds extensive interpretive comment in the notes, his method being often as quiet as Atget's). It is an enigmatic still life: On top of what may be an old dresser is stacked a rough pyramid of objects—a large and a small chair, a large and a small shoe, and a large and a small picture (apparently both photographs) of a giant and a dwarf together; the small picture, which is framed and is more abstract by virtue of being printed in higher contrast, and is thus perhaps suggestive of art, is placed in front of the large and unframed one and obscures the fact that the dwarf in the large picture is standing on a stool, though the small picture makes this clear; above the entire assemblage hangs a light bulb, illuminating nothing because the objects are in sunlight, though the bulb is a graceful shape (evocative of fruit? or a tear?) and serves to complete the composition; along three sides of the picture run borders of lath and composition board, the edges of a stage; darkness fills the background. The more one contemplates this beautiful photograph, with its rich tonalities, intricate shapes, and reflexive ambiguities, the more it seems to convey Szarkowski's understanding of the nature of art and its place in life. Atget's pictures embody for Szarkowski, I think, a celebratory and enabling nominalism, a nominalism probably not held as a final position but as a kind of interim one for life.

In answer to the question of why these books are the best to have been published so far about a photographer, there appear to be at least two reasons. One is that they have

been prepared by a notable team: Not only has Maria Morris Hambourg performed a vital service by giving us the facts of Atget's life and decoding the chronology of his work (in volumes two and three), but Richard Benson has translated the photographs into astonishing, compelling halftones.

Without Szarkowski, of course, the books would never have been undertaken, and central to his success seem to me to be the experiences and values of his own that parallel Atget's, and that must have helped Szarkowski understand his subject: Szarkowski was himself a photographer ("The hard part," he once joked as he tried to relearn darkroom skills, "isn't the decisive moment or anything like that—it's getting the film on the reel"), both men are notable for a catholicity of interests, and both show an unusually strong response to nature.

The main resemblance between them is, however, in the conception that Atget holds of his job as a photographer and Szarkowski of his as a critic. In the first volume of *The Work of Atget* Szarkowski suggested that Atget's achievement may finally be attributable to the fact that his goal—at its simplest to "describe the authentic character of French culture"—was larger than the expression of his ego; Szarkowski concludes his introduction to *Modern Times* by observing that Atget's example "makes us hope to see again artists not as gods but angels," not as autonomous creators but as creative celebrants of what is given. No sentiment could be more out of fashion, and none could better account, when applied to the critic as well as the artist, for the success of this study. Just as an artist can effectively show us life only if he or she steps partly to one side, so too a critic must, as Szarkowski does, acknowledge and even welcome the primacy of his subject.

Like any classic, this study raises controversial issues. Szarkowski quotes, for instance, a commentator who asserts

XXVII Eugène Atget, *Fête du Trône*, 1925

that Atget "did not make invidious comparisons between new and old," and Szarkowski may want to agree with that, believing as he does so strongly in Atget's openness to life. In view of all the modern world that Atget chose to ignore, however, and the depth of his feeling for the old gardens, it is arguable that his work is elegiac, even if affirmative (as to a lesser degree seems that of Walker Evans, whose views of America in the 1930s contained so many affectionately observed anachronisms). This is something Szarkowski might not contest too strongly, however, since sadness over the loss of Eden is human, even if inconsistent with a total embrace of the world. More debatable, perhaps, is Szarkowski's proposition that "the first demand that we make of a major artist, famous or nameless, is that subsequent artists be moved by his or her work, and take from it"; the priority seems uncharacteristically more that of a curator than a general viewer.

Probably the most likely contention to arise will be the one that follows any great interpretive study—that it reflects the worldview of the author more than that of the subject. Szarkowski has built a strong basis for his interpretation, however, by reproducing more than enough pictures to prove a consistency of vision throughout many periods of Atget's work, thus establishing those pictures, to which Szarkowski turns always as his primary evidence, as expressive of Atget's intent.

The books will be welcomed by generations of readers because Szarkowski's observations reflect such a strong commitment to seeing the pictures on their own terms, and to winning our affection for them by showing us that those terms are ours as well. Here, for example, is a note from the back of *Modern Times* about the transparency of photographic art, and in particular the beauty of a picture of a tiny house: "It seems a picture that anyone, everyone, would have made

exactly like this, at this distance and orientation and at this time of day and year; it seems a subject that anyone would have recognized for its perfection and importance, and photographed just like this, with perfect clarity and philosophical disinterest; it seems scarcely a picture, but rather a house, in which we think we might like to live."

WORKING CONDITIONS

XXVIII Timothy O'Sullivan, *Canyon de Chelly, New Mexico Territory*, 1873

IN THE
NINETEENTH-CENTURY
WEST

WE TRY HARD not to be sentimental, not to feel more emotion for a subject than it deserves. Old pictures like the ones in this book are, however, sometimes cited as temptations. If the open America we loved is gone, then its recollection and the grief that it inspires may be useless.

The force of this argument comes from our shock at the state of the current West. When else has a region of more than a million square miles been so damaged in so short a time? We catch ourselves thinking, in the bitterness that can accompany the unexpected sound of an aluminum can bending underfoot, that it would have been merciful if Columbus had been wrong and the world flat, with an edge from which to fall, rather than a circular cage that returns us to our mistakes. The geography seems hopeless.

It is true, admittedly, that the West has historically been filled in a series of sudden invasions, and that our present experience is in certain respects no different. The invasion

This essay was first published as the introduction to *The American Space: Meaning in Nineteenth-Century Landscape Photography*, edited by Daniel Wolf and published by Wesleyan University Press in 1983.

that followed in the two decades after the Civil War—the time when most of these pictures were made—was itself facilitated as ours has been by new technology (theirs included such things as the invention of barbed wire and the completion of the transcontinental railroad). It was a period as well, like ours, of extraordinary brutality; John Muir observed, as did others, that "nearly all railroads are bordered by belts of desolation," perhaps referring to events like the killing of more than a million buffalo for their tongues alone. Even the junk the early intruders scattered forecast ours; a new arrival to Denver in 1869 wrote that "the prairie is littered for miles with old tin cans and empty bottles."

What sets our recent experience apart, though, is first of all the scale of what has happened. It would not have been especially hard in the early part of this century to have retraced exactly the early photographers' travels, but by the 1960s and 1970s one would have had to have been a confirmed trespasser; thousands of miles of roads were abruptly walled off by "private property" signs (meaning, often, corporate property), and even if one made it through to the photographers' vantage points one was likely to discover that their subjects were flat gone—the Salt Lake Valley under smog, many of the canyons under water, Shoshone Falls reduced to support irrigation, Mono Lake drained down the aqueduct to Los Angeles . . . Suddenly the size of the American space proved no defense.

The first useful thing of which the nineteenth-century photographs remind us is, I think, that space is not simple. We have tended to think it remained until we marked it off with fences or roads, or until we put buildings in it; if we could see to the horizon free of these things we assumed space remained. But as a short walk in the Southwest now often proves, it may be possible to see little but rabbitbrush

for miles and still to know that the area is overpopulated.

Among the most compelling truths in some of the early photographs is their implication of silence. Western space was mostly quiet, a fact suggested metaphorically by the pictures' visual stillness (a matter both of their subject and composition). What sound there was in front of the camera a hundred years ago usually came from the wind, though even that stirred few trees; running water, though it appears in some of the pictures, was an exception; relative to the East there were not even many birds.

Now the noise level is of course far greater. The degree of change is demonstrated nearly everywhere, but I remember learning its complexity once as I photographed a remote church on the Colorado high plains; throughout the afternoon I studied the outside of the building from locations in the open fields to all sides, and alternately looked at the expanse from inside the church, through its simple lancet windows (one of the mysteries of space being that it sometimes seems bigger through a frame); at dusk I watched a line of clouds on the eastern horizon, white and rose, and then lightning far away in Nebraska, silent. In the morning, however, the place disappeared in sound. At first it had all seemed to be whole with the previous day; a coyote barked, the sun rose through a mist, and wildflowers opened. As I worked to set up a camera, though, there began and built to full volume in three or four seconds a noise of indescribable intensity; I turned to see a fighter plane, no more than two hundred feet off the ground and to the side of me, emerge from the haze and then disappear back into it, the heavy, terrible rush of its engine fading for many seconds out across the prairie. Eventually all was as quiet as it had been before, but the identity of the place, an identity dependent on the unbroken silence of space, was lost to me.

Another quality of space of which I am reminded when I

look at the old photographs is the easy tempo of life in it—often space looks nearly unmoving—and by extension the tempo appropriate for anyone who hopes to experience space. The pin-sharp views (how long did the photographer have to wait out the wind?), made only after establishing what amounted to a little camp in order to prepare the plates, and then taken only by substantial time exposure, suggest through the photographer's patience an appropriately respectful acknowledgment of the geologic and botanic time it took to shape the space itself. How can we hope, after all, to see a tree or rock or clear north sky if we do not adopt a little of their mode of life, a little of their time?

To put it another way, if we consider the difference between William Henry Jackson packing in his cameras by mule, and the person stepping for a moment from his car to take a picture with an Instamatic, it becomes clear how some of our space has vanished; if the time it takes to cross space is a way by which we define it, then to arrive at a view of space "in no time" is to have denied its reality (there are in fact few good snapshots of space). Edward Hoagland once observed that Walt Whitman would have enjoyed driving, which is surely true in the sense that he loved to see all he could so that he could assemble those long catalogs of his; after a few days at the wheel, though, I suspect Whitman's love of space might have brought him back to walking, since only at that speed is America the size he believed it. William Stafford has written accurately in "Prairie Town" about the relation of time and walking to the settlement of open America, about

Pioneers, for whom history was walking
through dead grass
And the main things that happened
were miles and the time of day.

Space does, it is true, occasionally have other speeds, as of antelope, which can run as fast as a car, though only for a brief while, but the common pace is more like that of tumbleweed, comic plants that wallop along at a rate we can usually match on foot (farmers on the plains have regrettably now found ways to strip wild growth from fence rows, denying us the plant's reminder of the velocity by which space is preserved). Little wonder that we, car-addicted, find the old pictures of openness—pictures usually without any blur, and made by what seems a ritual of patience—wonderful. They restore to us knowledge of a place we seek but lose in the rush of our search. Though to enjoy even the pictures, much less the space itself, requires that we be still longer than is our custom.

Another subtlety of space of which the photographs constructively remind us is the shaping, animating part played there by light. All landscapes are defined by the sun, but the intensity of the sunlight in the West sets the region apart (Nabokov observed that only in Colorado had he seen skies—so clear that if one looks straight up they appear blue-black—as there were in central Russia). The early photographers were limited in what they could show of variations in the sky, but they effectively suggested the power of light by juxtaposing bright, bleached ground against areas of deep shadow.

One remembers those pictures now, with their impression of arcing light, when one visits places like the bluffs above Green River, Wyoming, and sees there the numerous sources of aerial contamination that on some days make it look like the Ruhr, the sky dulled. Physically, much of the land is almost as empty as it was when Jackson and O'Sullivan photographed there, but the beauty of the space—the sense that everything in it is alive and valuable—is gone. Exactly how this happens I do not think can be explained, any more than

can the opening verses of Genesis about light's part in giving form to the void. But the importance of pure light is a fact for any photographer to experience; with it pictures of space are easy, and without it they are a struggle. Though the difference between a clean sky and a smoggy one is not felt just by photographers. How emphatically absolute the distinction can be—we might at first suppose air pollution to be insubstantial and relative—was synopsized for me by the reaction of a woman who arrived in Denver in the 1960s to consider it as a home for her family; almost at once she phoned her husband, who was working in Connecticut—he had been stationed in Denver during the Second World War—and said simply, referring to the landscape he had seen, "It's not here anymore."

Each of these aspects of space—its silence, its resistance to speed, and its revelation by light—seems to me usefully emphasized by nineteeth-century photographs because even today there are fragments of the American space to be protected, and that is something that is more likely to happen if we are clear about the nature of what is threatened. The difficulty is, however, that we do not seem much to love what space there is left. One thinks not only of the greed of developers, which is numbingly obvious, but of a widespread nihilism that now extends through much of the population, witness the reflexive littering, the use of spray paint on rocks, the girdling of trees near campgrounds, and the use of off-road vehicles for the maximum violence of their impact. The West has ended, it would seem, as the nation's vacant lot, a place we valued at first for the wildflowers, and because the kids could play there, but where eventually we stole over and dumped the hedge clippings, and then the crankcase oil and dog manure, until finally now it has become such an eyesore that we hope someone will just buy it and build and get the thing over with. We are tired, I think, of staring at our corruption.

The sadness of this is, as the foregoing consideration of some of the qualities of space suggests, that areas of the American West are not wholly irredeemable. Though cities will not be unbuilt (some may disappear for lack of water), at least certain aspects of space, as suggested by the early pictures, could be partially restored—the land's quiet, its impression of size and stability when encountered slowly, and its sun-irradiated beauty. Some places could, in short, be emptied. We could control sound pollution by regulating the design of tires, by outlawing dirt bikes, and by restricting routes open to airplanes; we could reduce the speed at which we travel through open country, not only by enforcing lower speeds on highways and waterways but by excluding motor vehicles entirely from whole areas; we could certainly better regulate light-impairing air pollution. Half-damaged though the land is, we could keep what remaining space we have from shrinking, and perhaps even learn how, as the Japanese do with gardens, to make what there is seem, by our understanding care of it, bigger than it literally is, more spacious. At least there is no reason for a state like Kansas, with its ever-present horizon line, to seem small. Theodore Roethke, in a poem entitled "In Praise of Prairie," described the peace that we might achieve:

> *The fields stretch out in long unbroken rows.*
> *We walk aware of what is far and close.*
> *Here distance is familiar as a friend.*
> *The feud we kept with space comes to an end.*

The possibility of such a reconciliation, based on the fact that some of the American space is recoverable, is part of what keeps the pictures from being of only sentimental interest. To love the old views is not entirely pointless nostalgia, but rather an understandable and fitting passion for what could in some measure be ours again.

The condition of the western space now does raise questions, nonetheless, about our nature. When I think, for example, of Denver, I wonder if we can save ourselves. On grassland northeast of the city the Rocky Mountain Arsenal has buried in shallow trenches, without record of location, wheat-rust agent made originally for germ warfare; the dump stands upwind of the American wheat bowl, and there is apparently nothing to prevent prairie dogs or a badger from someday opening it. To the west of the city, meanwhile, tableland has been so contaminated by fugitive plutonium from the Rocky Flats Nuclear Weapons Plant that developers have been forbidden to build there, the space having been poisoned for many generations to come. If we can do these things—and they are not by any means isolated evils—are we capable of decent behavior? (It is a doubt that qualifies our enthusiasm even for the achievements of NASA.) Is what has happened to the West a matter for social scientists, who take a mechanistic view of man, or for theologians, who see us as moral beings capable of choice?

The best answer to this unanswerable conundrum seems to me to be the compromise offered by classical tragedy. The plays are convincing, I think, because they falsify neither side of our ambiguous experience, which is of both freedom and fate—freedom as we know the world to be more exciting than the monotonies of a naturalistic novel, and fate as we live in a world worse than anyone could have desired.

In the plays of Sophocles and Shakespeare the hero is shown to believe, in ignorant pride, that he is godlike, which is to say free, and to learn through suffering that his freedom is paradoxical—to accept limits. Although presumably the photographers who took the early landscapes did not intend such an analysis of our country, since they witnessed no more than the opening events, their pictures do lead us now to reflect on a tragic progression. They remind us of the

opportunity the openness provided for the confusion of space and freedom, an understandable but arrogant mistake for which we all now suffer.

Space as we see it in the early pictures was not just a matter of long views, but also of distance from people. Many of the scenes are completely unpopulated, lacking any signs of man at all. Where there are figures they seem mostly to have been drafted from the photographer's party. And when there are buildings or railroads they often appear to have gotten the photographer's attention precisely because their presence was unusual.

In front of such landscapes it is easy to sympathize with those who lived out the early acts of our national misunderstanding of space. Little wonder that Americans said so confidently and unqualifiedly that they were free. How could they be otherwise—they were alone, or so it seemed. And they had gotten there as a result of their own effort. One of the striking things about many pioneer journals is that though the events described sound inexorable (disease, accident, failed crops), the feeling expressed is of having chosen the life. Even in accounts of river travel, where the course was set, there was a sense of liberty; Huck Finn, Twain's incognito, expressed it almost every time he shoved the raft away from the bank, and Major Powell, no matter how deep in the confines of some gorge, wrote as if he were carried along mainly by the engine of his own enthusiastic choice.

At its best this equation of freedom with isolation from others has been understood as liberty to know oneself. In the words of Rosalie Sorrels, the composer and singer, the West "is the territory of space . . . a place where people have gone so that they could hear the sounds of their own singing . . . so that they could hear their name if they were called . . . so that they could know what they think." It is

impossible even now, even after our tragedy, not to admire the spirit of that. One wonders, for example, if Abraham Lincoln's character would have been the same had his family not been the sort to keep moving west as soon as they saw the arrival of neighbors.

A consideration of space and freedom and the American West begins logically, in fact, with the Civil War, a war about freedom (it also marks, conveniently, the starting point in America for serious, extensive landscape photography). A significant amount of the war was fought along the edge of the American space, and some even in it, as at Glorieta Pass, New Mexico. And the war's conclusion made possible the beginning of the great invasion of western space. Indeed, as has often been pointed out, had those who enacted the war not been allowed to migrate in numbers into the West it is hard to see how the hatreds would have cooled as they did.

Barnard's pictures of holes blasted in the woods stand as frightening metaphors for what would follow the war; the bare ground and broken trees synopsize what was to be our violent assertion of our own space in space. As do all wars, the Civil War produced a generation of people tired of trying, of paying for ideals, and the condition of the West is to be explained in part by that generation's cynicism and the pattern it set. Many immigrants saw their separation from others as a welcome freedom from responsibility. Liberty meant leaving people, whatever their needs, behind. We became a nation of boomers, everlastingly after a new start out in the open, by ourselves.

This morally indefensible equation of space, understood as distance from others, and freedom, understood as license to pursue one's own interests without regard for those of others (no one else being in view), has ended of course in the reduction of everyone's freedom. While the apparently infinite number of opportunities to start again stretched

away westward, the mythology of capitalism appeared plausible. Anyone could, if the compulsion of his greed were left alone by government, go into the space, which was luckily well stocked with natural resources, and by work become rich. Mounting evidence to the contrary has for the most part been censored out in public education and the press, both influenced by profiteers, until now things have gone so far that the space has nearly been denied us. Ironically, corporate capitalism has for a century been allowed such sway that it has now, in the name of economic efficiency, almost cleared the space of exactly the people who wanted to enjoy it—small farmers, miners, and ranchers. We are left an urban nation, one today largely prohibited even visiting rights to the country. We look back at the early pictures and marvel that the sheer size and beauty of the space could have absorbed and hidden for so long the damage done by unrestrained self-interest. Our destiny is to suffer the imprisonment of places like Los Angeles, with its twelve-lane "freeways," though whether in this we have the courage to find self-knowledge remains unclear.

What is the relevance of these old photographs, then, to a country that has enacted a tragedy, that has, in Theodore Roethke's words, "failed to live up to its geography"? Part of the answer is that the pictures tell us more accurately than any other documents we have exactly what we have destroyed. With the pictures in hand there is no escaping the gravity of our violence; the record is precise, as exact as the ruler O'Sullivan photographed against Inscription Rock in New Mexico.

What we are forced to see is that the West really was, despite all the temptations there are to romanticize the past, extraordinary—as extraordinary as the great flow of the Columbia River, the rock spires in Canyon de Chelly, or

the deep space above the Sierra. The pictures make clear that before we came to it in numbers the West was perfect. The camera, as used by O'Sullivan and Jackson and Watkins and Hillers, refutes every easy notion of progress, every sloppy assertion that we have improved things (early land promoters on the prairie actually argued that settlement would increase the rainfall!). When we look at what was there before us we are compelled to admit with the poet Cid Corman, "How obvious it is I couldn't have imagined this."

One way to judge the importance of the photographs is to compare them to paintings from the same time. Enough landmarks remain in something like their original form to check both photographers and painters against identical subjects, and with few exceptions the photographers come off better. I think for example of the painting now in the White House by Thomas Moran of the bluffs at Green River, a picture in which the sky seems derived from the English moors, lush and moist. It is a fiction, as are most of Moran's finished paintings, just as are those by Albert Bierstadt, the other celebrity painter of the time.[1]

There are in fact only a few accurate nineteenth-century western landscape painters—Karl Bodmer, John Henry Hill, Worthington Whittredge, and Sanford Robinson Gifford are the only ones I would care to defend—and for the most part they made their reputations elsewhere, their contact with the West having been brief and geographically narrow.[2] By contrast, photographic careers of lasting importance were built almost entirely in the West, and evidence a longer and wider acquaintance with the landscape.

Why painting, which earlier had flourished as a record of space along the eastern seaboard, succeeded so little in the West is a matter of speculation. The photographers may in some cases have been helped by the fact that their job was usually first to make a clear record for the War

Department or the Geological Survey or the railroads; it was the sort of assignment to keep one moving and save one from pretense. But some of the painters were given similar priorities.

One suspects that the freshness of the photographic enterprise may have helped—the fact that there was a new way to see. Something at any rate appears to have built an enthusiasm that in turn contributed to endurance, and since the longer one is in a landscape, especially a spare one, the more one is likely to love it, it gave them an advantage, art being in the last analysis an affirmation, a statement of affection. Jackson, for instance, when he lost his job with the Geological Survey, never seriously considered leaving the West: "Whatever I might find for myself," he wrote, "it must be in some great open country." Few painters were that committed to the place. The photographers were the ones who were in it for keeps, and who were intoxicated by some of the spirit of that ad for film (recorded by Steve Fitch) on the road to the Grand Canyon—"Hit the Rim Loaded." It was fun. O'Sullivan is quoted, for example, as saying even of the desolate and mosquito-infested Humboldt Sink that "viewing there was as pleasant work as could be desired." One supposes that the spellbinding nature of photography led them on just as it does us—the fact that in one take you can get it all, right down to the individual leaves on the sagebrush.

The chief reason the photographers did better than the painters, though, was that when the painters were confronted with space they filled it with the products of their imaginations, whereas photographers were relatively unable to do that. The limits of the machine saved them. If there was "nothing" there, they had in some way to settle for that, and find a method to convince us to do the same. Generally speaking, the painters imposed Switzerland on the Rockies, for

instance, producing western landscapes that were crowded rather than spacious; they turned mountains vertiginous, hung thick atmospheric effects on peaks and through valleys, and placed in the foregrounds camps and grazing animals. Though photographers could and did steepen the apparent grade of mountains, they could only imperfectly register clouds (some like Barnard tried to print in skies from second negatives that had been exposed specifically to record them, but the composite usually betrayed itself at the horizon), and they hadn't any chance at all, with their slow apparatus, of stopping camp activity or wildlife.

Nineteenth-century photographers of the West could not, in short, often bring landscapes to intense dramatic focus, as could painters, because they could not add to them. If the middle was empty, that was the way it had to be shown. (They could of course fill pictures with eccentricities like Shoshone Falls and El Capitan, but the meaning of these spectacles was ultimately to be found in the norm they exceeded, so that to concentrate on them exclusively would have produced a record as pointless as those tourist slide shows that unrelentingly take us to every spring and geyser in Yellowstone.) At their best the photographers accepted limitations and faced space as the antitheatrical puzzle it is—a stage without a center. The resulting pictures have an element almost of banality about them, but it is exactly this acknowledgment of the plain surface to things that helps legitimize the photographer's difficult claim that the landscape is coherent. We know, as we recognize the commonness of places, that this is our world and that the photographer has not cheated on his way to his affirmation of meaning.

Among the reasons for enjoying the experience of space is the proof it offers of our small size. We feel in its presence the same relief expressed by the man who in 1902 managed

to drive his car—the first one ever—to the edge of the Grand Canyon: "I stood there upon the rim of that tremendous chasm and forgot who I was and what I came there for." It had apparently been one of those journeys away from oneself, in search of awe—a drive we still make.

Insofar as the western photographers were artists, however, their work helps us beyond a humbling realization of our small size to a conviction of our significance as part of the whole. We and everything else are shown, in the best pictures, to matter. The photographers' experience was, it seems to me apparent from the pictures, finally not just of the scale but of the shape of space, and their achievement was to convey this graphically.

What they found was that by adjusting with fanatical, reverential care the camera's angle of view and distance from the subject, they could compose pictures so that the apparently vacant center was revealed as part of a cohesive totality. They showed space as itself an element in an overall structure, a landscape in which everything—mud, rocks, brush, and sky—was relevant to the picture, everything part of an exactly balanced form.

Art never, of course, explains or proves meaning—the picture is only a record of the artist's witness to it. He or she can, however, be a convincing witness. In the case of these pictures we are helped to belief, I think, by the photographic approach—the views are mostly long shots that have been made with normal lenses (lenses that approximate the breadth and magnification of average human vision). It was a method that restricted the photographer's opportunities to control our view of the subject (his only ways substantially to alter the composition being to hike farther, or to wait or return for different light), but the sense of objectivity it conveys tends to neutralize our skepticism. It is obviously easy to assert that life is coherent, but to

work out the visual metaphor for that affirmation from within the limits of an almost antlike perspective is hard and remarkable. One is reminded of George Steiner's definition of classicism as "art by privation." What kind of art could be more convincing in the depiction of the Southwest, of the desert, of a landscape that is by common standards deprived?

To go beyond showing mere size to a demonstration of form is important because awe by itself, without an accompanying conviction of pattern, can easily give way just to fear. Job was at last reconciled to life not by being shown only that he was small and therefore necessarily ignorant, but by being reminded of mysteries that are part of a Creation in which all elements are subordinate to a design; the world, God tells Job, is a "vast expanse" but regulated by seasons, the heavens are immense but divided and given shape by stars like those in the Pleiades, and the oceans are an "unfathomable deep" but the appointed home for whales. By contrast it is an attention to size alone, at the expense of pattern, that makes so much romantic art so discomforting. One wishes romantics were compelled more often to live on the ocean or the prairie, where they could discover to what lengths the size of space might drive them. Ahab was fiction's hyperbole, of course, actually doing battle with the inarticulate expanse, but his compulsion is there for any of us still to suffer, even if more passively. I think, for example, of a man of whom I know on the Colorado prairie, an ex-submariner who has relegated his orthodox house to storage and moved below ground into a roofed-over foundation, safely submerged.

To the extent that life is a process in which everything seems to be taken away, minimal landscapes are inevitably more, I think, than playgrounds for aesthetes. They are one of the extreme places where we live out with greater than

usual awareness our search for an exception, for what is not taken away. How else explain, finally, the power of the best nineteenth-century landscapes of space except as they result from this struggle?

Timothy O'Sullivan was, it seems to me, the greatest of the photographers because he understood nature first as architecture. He was our Cézanne, repeatedly creating pictures that were, while they acknowledged the vacancy at the center (a paradoxical symbol for the opacity of life), nonetheless compositions of perfect order and balance. Like Cézanne, O'Sullivan's goal seems to have been, as Cézanne phrased it, "exciting serenity." Each was an artist/geologist, in love with light and rock.

O'Sullivan came to the convictions he expressed in his western pictures by way of experiences that must seem to us now especially relevant; he began by photographing war. Sometimes this involved taking staid shots of units behind the lines, as he did of soldiers attached to the headquarters for the army of the Potomac, shown drawn up in ranks, and as he did of a contingent of over two hundred wagons and teams assembled perfectly into formation. On other occasions, however, he photographed in the midst of combat, as at Fredericksburg, or in the aftermath of combat, as at Gettysburg, where he made among the most desolate pictures ever taken of war's results. In one such view he recorded a meadow littered randomly with bloating corpses; the head of the nearest tilts toward the camera, mouth agape as if caught midscream, while in the distance a living officer sits placidly on his horse, forecasting the grandiose, lying statuary to come. Another picture shows bodies that have been dragged by a graves detail into a ragged line, a grotesque approximation of parade-ground order.

Nietzsche observed that "whosoever has built a new Heaven has found the strength for it only in his own Hell,"

and this it seems to me must to some extent have been the origin of O'Sullivan's western landscapes. More than any of the other photographers, O'Sullivan was interested in emptiness, in apparently negative landscapes, in the barest, least hospitable ground (he did little with the luxurious growth in Panama, where he visited briefly). The preponderance of his best pictures are of vacancies—canyons or flats or lakes, the latter rendered as silver holes reflecting the space of the sky. In them he compulsively sought to find shape, to adjust his perspective until the plate registered every seemingly inconsequential element in balance.

The uniformity of emphasis in such pictures—the overall order, but often without a dramatic center—has recommended them to some modern photographers and painters who see the world as nonhierarchical, and who therefore themselves photograph or paint in ways that emphasize all components equally. This bias has tended to obscure, however, what was for O'Sullivan, I suspect, a different goal—to counter the leveling confusion he witnessed in battle. It is hard in fact not to see the ambulance he used to carry his equipment through the West as a metaphor, though it obviously wasn't meant that way, for what appears to have been his wandering recovery from the disintegration he pictured at Gettysburg. Because the fact is that the landscapes he made in the West affirm with obsessive consistency an order larger than the one he saw blasted away, an order beyond human making or unmaking. The pictures themselves are human compositions, but they refer to a design that is independent of us.

O'Sullivan was, from what little evidence there is, a likable, outgoing man—apparently a storyteller, notoriously profane, and respected enough by his companions frequently to be put in charge. Despite his gregariousness, however, he infrequently made people his first pictorial concern. He may not

XXIX Timothy O'Sullivan, *Sand Dunes, Carson Desert, Nevada*, 1867

have been skilled at portraiture, but one also suspects that by the time he got to the West people did not much interest him as photographic subjects. Except, and it is an important exception, as their response to nature interested him. The best picture he made at the Zuni pueblo, for instance, was not directly of Indians but of their walled gardens at the edge of the desert. And among the finest pictures O'Sullivan ever took were those at Canyon de Chelly, a place where people had for centuries lived harmoniously in a reserve of rock. It is interesting to recall as background for those pictures, however, what O'Sullivan surely knew as he photographed there in 1873—that in January 1864, while the Civil War continued in the East, Kit Carson had led federal troops into the canyon, and there killed or captured what Indians he found (they were starving and freezing) and as a final stroke ordered the destruction of some five thousand peach trees that the Indians had lovingly tended on the canyon floor. Against these events O'Sullivan's landscapes, which are filled with light and stillness, stand as profound meditations.

It has been suggested, mostly on the basis of O'Sullivan's having worked for Clarence King's surveying expedition through the West, that O'Sullivan not only shared King's interest in the "catastrophes" recorded in western geology, but also King's belief that the earth's history is determined by catastrophes. In such a reading the pictures (which do often show geologic upheavals, as are to be seen throughout much of the West) are ominous, and any divinity responsible for them hostile.

Though O'Sullivan certainly suffered the catastrophe of the war and thus might have been attracted to the topic in general, it seems to me doubtful that the pictures of the West were taken as an indictment of the nature of life. For one thing, the pictures he made of the war's casualties did

that in a way so absolute that anything more was redundant. As for King's influence (and to a lesser degree that of George Wheeler, O'Sullivan's other superior in the field), presumably they did talk philosophy around the campfire, but that does not itself establish what O'Sullivan, very much his own man, believed. The pictures are the only dependable evidence we have about that, and the persistent impression they give is of calm, of stasis, which does not really accord with a philosophy of turmoil. O'Sullivan undoubtedly pictured many things at King's request, but his treatment of the subjects suggests that the director of the project may not have understood what motivated the photographer (this kind of innocence is not unusual; Roy Stryker, who supervised photographers working for the Farm Security Administration in the 1930s, had for example little grasp of what one of the best of them, Walker Evans, was trying to do). It is worth adding, finally, a truism from the experience of many landscape photographers: One does not for long wrestle a view camera in the wind and heat and cold just to illustrate a philosophy. The thing that keeps you scrambling over the rocks, risking snakes, and swatting at the flies is the *view*. It is only your enjoyment of and commitment to what you see, not to what you rationally understand, that balances the otherwise absurd investment of labor.

Whether O'Sullivan's pictures and those of other nineteenth-century landscapists suggest a hostile universe comes down, I think, to expectations. If we require a world designed for us, then the West they pictured is threatening, even malevolent. Alternatively, however, we can try as they did to see the landscape from a less self-centered point of view, and perhaps find in that perspective some consolation.

Admittedly the pictures do not suggest that life will turn easy. Cézanne is himself reported habitually to have remarked that "life is fearful"; Mont Sainte-Victoire was, like

much of the geography O'Sullivan photographed, a pitching mountain. The wonder of the paintings and photographs is, though, that in them the violent forms are brought still, held credibly in the perfect order of the picture's composition. Nothing is proven, but as statements of faith they strengthen our resolve to try to discover in our own lives a cognate for the artist's vision. In the case of O'Sullivan's vision, typified as it is finally by the intense quiet of Canyon de Chelly, we note how arduously it was earned, coming only by way of the scream at Gettysburg. O'Sullivan's western pictures are, to borrow a phrase from Roethke, the achievement of "a man struggling to find his proper silence."

1. It is true that many preliminary studies by Bierstadt and Moran are convincing, suggesting that part of the problem may have been the necessity of doing the finished paintings (which tended to be large) long afterward, far removed from the subject. The changes that the two made, however, were always additions in the direction of Wagnerian theatricality, and it is impossible not to conclude, when confronted by studies so uniformly better than the finished works, that the painters did not understand what they were doing; with Bierstadt and Moran we are reminded of Goethe's observation that "genius is knowing when to stop." Other landscape sketchers in the West, though perhaps not geniuses—men like Seth Eastman, John Mix Stanley, and Frederick Piercy—did usually content themselves with what they recorded on the scene, and thereby left us records of less ambiguous value.

2. The finest landscape painter of the American wilderness in the second half of the nineteenth century, Winslow Homer, never came west, and the great realist, Thomas Eakins, visited the West only one summer, leaving as his best record of the experience two photographs of cowboys. Of the other major painters whom one supposes might have dealt credibly with the American West, Frederic Church traveled extensively but never to the West, and John Fredrick Kensett, though he did get to a little west of Denver, apparently was there too briefly to understand what he saw (his sketches are uncharacteristically exaggerated).

IN THE
TWENTIETH-CENTURY
WEST

ON THE PRAIRIE there is sometimes a quiet so absolute that it allows one to begin again, to love the future. Such moments are a surprising blessing because the grasslands, at least in northeastern Colorado where I walk, are weighed by the future—they are recklessly cultivated and overgrazed, and are the location every few miles of nuclear-missile silos.

One summer afternoon, in the stillness that seems a part of the cloud shadows that move over the land, I stopped photographing and gave myself to thinking about a dream: What if there were a specific site here where those concerned with threats to the future could come, and in the silence of the prairie, strengthened by the knowledge that others had come here in concern before, focus their thoughts on changes needed to safeguard life? Perhaps the spot could be marked by a stone with a few words, perhaps a stone in dry ground above an arroyo with a little water, or on a hill

Originally entitled "In the American West Is Hope Possible?," this essay was first published in *The North Coast Times Eagle*, Astoria, Oregon, 1986. Later it was incorporated into the book *To Make It Home—Photographs of the American West*, 1965-1986 (Aperture, 1989).

in a stand of poplars planted for the wind, for birds, for the gold of fall—a place to which we could bring the harmony of our prayers.

It even occurred to me, in the expansive way of hope, that such a place would be better if it were approached the ninety miles from Denver on foot, by a path. I knew that between Denver and the grasslands there were now corporate farms, patrolled and fenced, but the dream was so sustaining that I tried to hold to it.

Part of our difficulty is the extreme to which things have gone. Important qualities common to life through much of history are now almost lost. What does the texture of our experience in suburban America, for example, share with the daily circumstances of those who lived in rural nineteenth- and early twentieth-century America? Imagine walking in summer a hundred years ago down a street in a small town in western Nebraska. You might hear almost nothing, or just the wind, or a wagon and children and a dog. It is a scene nearly beyond our reach—farther from us than walking the moon, radios crackling. In the town whole lives were passed, hour after hour, year after year, in quiet. The lives included joys and sorrows that we know, but the context in which these were felt was fundamentally different from ours.

Thoreau in the 1840s took comfort in being able to escape even what he sensed were the noisy intrusions in small towns. In his essay "Walking" he celebrated the fact that he could "easily walk ten, fifteen, twenty, any number of miles, commencing at my door, without going by any house." He wondered "what would become of us if we walked only to a garden or a mall?" He was innocent, of course, of the degree to which the question would be forced, of the fact that eventually no one would be able to find one square mile in America free of the imprint of man.

The sadness expressed about this condition by writers such as Edward Abbey, Edward Hoagland, and Peter Matthiessen, and understood by everyone who has known open country, is equaled at only a few points in the American experience—at the end of the nineteenth century, most notably, when Indians realized that they were defeated for the rest of their lives. There can never be again, for example, as there was for the Oklahomans who lost their farms in the Depression, a California to which to escape.

What is frightening in this loss is the corrosive, alienating bitterness toward which it has led. In the movie *Five Easy Pieces* (1970) there is a sequence that has come to synopsize it: The protagonist, driving north from Los Angeles to Puget Sound, picks up two young women hitchhikers and asks where they are going. They reply Alaska, where it is "clean," and explain, with barely controlled rage, that things in the lower forty-eight appear to them to be "shit." They reiterate the word, and when the film is shown to university audiences now the students sometimes repeat it as a litany of their own disgust. Who hasn't, after discovering a favorite mountain cut clear, or garbage on the beach, or a hawk torn from a cottonwood by gunfire?

Though distress over such things is shared now in a general way by many, its severity is due to the fact that the cause is always particular, worse than any torment by statistics. As Henry Beetle Hough, the late editor of the *Vineyard Gazette*, said not long before he died, he was sorrier about the destruction of Martha's Vineyard than about the apparent fate of the world. We feel worst about losing the specifics of home.

The issue is not just that land developers have unbalanced the ecology and made much of the geography ugly. What strikes so painfully is that, at least in the perspective of our brief lives, they have destroyed the places where we became,

and would like to continue to become, ourselves. When I was fifteen, for example, I was hired in the summer to help take campers on horse pack trips through Rocky Mountain National Park. The landscapes I saw that season were for me formative, and have remained vivid in remembrance partly because of the hushed isolation in which we encountered them; it was unusual to meet anyone at all on the trail for days at a time. Twenty years later, however, it had become unusual to follow a major trail for more than five or ten minutes—minutes, not days—without meeting long lines of hikers. Officials referred to the place as an "urban" park, and in fact I discovered eventually that there was more privacy in City Park in the middle of Denver than in walking the high peaks. From City Park I could see the back range, white, and I could recall the days I had spent there—the dry clatter of granite, the alpine flowers, the cries of pikas. It remained there in memory, though if I went closer it disappeared.

There are many such stories, and the end of them all is that, by the mid-1970s, every last secret place was finished. And one's tenderness and hope were lessened. As a boy it never occurred to me, for instance, to take a gun camping for safety (I had slept outside more than a year by the time I was twenty, from Arizona to Montana). Then, however, as the urban population increased and elements of it went on mindlessly criminal forays into the countryside, carrying a gun became commonplace. Some people—pacifists, whom I respect—refuse to carry guns, but I myself would not now camp overnight most places in the West without one, particularly if I were responsible for the safety of a woman or a child. It is a reasonable precaution against the only dangerous wild thing left, people. Having the gun, however, and always remembering the reason for it, deeply mars the experience.

There are so many events that used to bring pleasure and don't any longer. Encountering animals, for example. I

remember the joy I knew the first time I saw a cougar, and later the same summer, a marten. And the satisfaction I felt when I realized I was with deer, in rimrock or sunny pines or in a canyon at daybreak. Now if I see deer, as I occasionally do along the Platte, it saddens me. Where are the wretched things to go?—in all directions there are highways, and the risk of attracting guard dogs.

Mention of such concerns to a generation of new immigrants (the population of Colorado grew by 30 percent in the 1970s), who are understandably impressed by the remaining sight of the Rocky Mountains, on smog-free windy days, brings puzzlement to them. And thus worse to me. To have grown up in Colorado and to be middle-aged now is to be old.

And sometimes angry. I think of one gray morning in October when I returned to a spot on the prairie where our West Highland terrier had been caught the previous day in a trap set for coyotes, a hellish device camouflaged in the middle of a public dirt road (legally, as it turned out). Kerstin had been injured in freeing the dog, and I was determined to remove whatever other traps there were nearby; I carried a pair of bolt cutters to do the job.

Can good be made of the anger I feel? Can I be saved from that anger? Can it by some alchemy be transformed to the quality that one critic found in Philip Levine's poetry—a "constructive bitterness?" Might we even somehow learn the hope of the Plains Indians who, photographed as if they were lunatics, danced the Ghost Dance, their final celebration of their dream of the land's restoration? The ceremonies were often held, judging by the images we have, in scrappy pastures right at the edge of their enemies' contempt.

Part of our disillusionment is a feeling common to people at any time. Keats expressed it: "To think is to be full of sorrow."

It is also a fact that there are more important issues than the loss of the West, threats that could make its fate minor.

And it is true, with respect to the landscape, that exceptions seem occasionally to mitigate its ruin. When I walk in southern California, in its wonderful verdancy, I am sometimes reminded of how defiant life is—under the gleaming leaves of eucalyptus trees, for instance, leaves that rustle like paper, and hide mockingbirds and lizards and aromatic seeds. It is always the larger juxtapositions, though, that call short one's relief. If you climb firebreaks up through the chaparral above the Los Angeles basin, for example, you are still likely to hear, eventually, the scream of a hawk, surely among the great primal sounds of nature; if, however, the air is polluted, and the cry is superimposed over the noise of dirt bikes and gunfire and the metronomic backup signal from some far-off landfill machine, then the cry will seem, in its acidity, only human.

Philosophers and writers have sometimes said we have to do without hope. The hawk apparently does not need it, and, in the absence of nuclear war, we would presumably hang on in some form without it, animated by our root unwillingness to die. On the evidence, however, hope is necessary to the survival of what makes us human. Without hope we lapse into ruthlessness or torpor; the exercise of nearly every virtue we treasure in people—love, reason, imagination—depends ultimately for its motivation on hope. We know that our actions come to little, but our identity as we want it defined is contingent on the survival of hope.

It might be thought, I admit, that insofar as the landscape is separable from people, hope for it is of lesser importance than hope for human beings; our Judeo-Christian tradition inclines us to this prejudice. I was reminded, however, in a late essay by Henry Beetle Hough of how interrelated these hopes can be. At the end of a discussion of the apparently

final deterioration of Martha's Vineyard, the formerly (and, I think, finally) hopeful man repeated two lines from a poem he did not identify except as being by Swinburne, noting that he had taken the lines out of context: "There is no help, for all these things are so / And all the world is bitter as a tear." The lines were so disturbing in their expression of defeat that I looked them up, and discovered their source to be a verse entitled "A Leave-taking," not about the passing of a landscape but about the death of a loved woman. I remembered that Hough's wife, with whom he had shared his affection for Martha's Vineyard, had died not long before, and it was clear the path by which he had come to be thinking of the poem as he wrote about the land. The two—the person and the place—were bound.

Though not as emotionally absolute as the loss of a person, the loss of one's home is so serious, I think, intertwined as it is with the rest of life, that it cannot be borne without learning, somehow, eventually, undoubtedly imperfectly, a faith. That is why we have to begin to conquer our bitterness over the loss of the West.

For generations little may change in the American political and economic system, at least without the impetus of some disaster, several of which are easily imaginable, but their occasion and consequences are uncertain. What does seem clear now, though, is that our government is not presently open to the fundamental reconstruction that would allow correction of the worst failures in our stewardship of the land. In part this is because there is no longer—if there ever was—a center of values, other than material ones, to which a majority subscribe, and in part it is because our political system has been corrupted (bought) by the economic system. Altering that economic system is, moreover, improbable in the absence of catastrophe, since most Americans are

convinced that it offers them opportunity, and thus that capitalism and democracy are appropriate to each other. (I believe that for most people the chance at wealth is illusory, that capitalism and democracy are in many ways antagonistic, and that there is a desirable affinity to be nurtured between democracy and socialism.)

Because our politics and economics aren't likely to change in the near future, I hold small hope that the American West, even significant parts of it, will remain open. The region's central, defining characteristic—space—is unlikely to be retained in anything resembling its original sense because, in accordance with our system of values, it is not as important as the chance to amass wealth.

Consider the current overpopulating of the Southwest. However much we might wish to continue welcoming all economically disadvantaged people to the United States, uncontrolled immigration from Mexico—a country Edward Abbey has correctly identified as potentially our hemisphere's India—has so seriously exacerbated the ecological crisis in the American Southwest that most who know that crisis firsthand oppose allowing the immigration to continue. But it has been permitted to do so, mainly because wealthy leaders of the American Right prefer that the United States absorb Latin overpopulation rather than let it foment revolution that might endanger investments in Latin America, and because illegal immigrants make up a cheap labor pool in the United States. We have sold a region of our country into further ecological imbalance in order to protect and increase the income of a few.

Or consider our national park system. At present it is mostly a reflection of nineteenth-century interests, amounting in the main to a collection of anomalies, geegaws in the glass cabinet of a Victorian parlor. What we need now and for the future is a system of parks that would allow us to

encounter not what have always been geographic oddities—caves, geysers, petrified trees, waterfalls—but what were large-scale typicalities—shores, forests, mountains, canyons, and prairies. To a small degree, we have set aside such places (often the most valuable parts of parks established for other reasons), but not in nearly enough size to convey to visitors the central fact of the undisturbed American landscape—its proportion to us, its grandness. And it is virtually impossible now to win approval for such parks because their creation would contravene economic priorities, witness the futile efforts over many years to create even a tiny park of representative tall-grass prairie in Kansas. The land is worth too much for the public to own. Capitalism may not be mentioned in the Constitution, but it is in fact our state religion, and we are ardent in living by it.

So, when I have the strength to be honest, I do not hope to experience again the space I loved as a child. The loss is the single hardest fact for me to acknowledge in the American decline. How we depended on space, without realizing it—space which made easier a civility with each other, and which made plainer the beauty of light and thus the world.

Admittedly not everything dies outright by crowding. What almost always perishes, though, is a loveliness that sustains our desire for life to go on and on. Think of the tens of thousands of horses penned across the suburban West, imprisoned in bare, cramped lots where they wait their lives for baled hay tossed from a station wagon. I have seen such horses standing at night in the glare of an adjoining shopping center, and wished that their lives would be short.

Resignation must be in some measure a necessary preface to hope. I don't feel much resignation, as is obvious from the foregoing, except for brief times—when I'm able to

photograph—but I see it and its value in others. Peter Matthiessen lightens his walk through the ecologically damaged Himalayas, as described in *The Snow Leopard*, by noting again and again Buddhist prayer flags, bright in the wind; Edward Hoagland, who has acknowledged that "the age of animals is ending" and that he cannot write about them anymore, nonetheless retains a commitment to write about the complexities of human interaction with the land, a commitment that requires the energy of hope; Edward Abbey, who has been forced to console himself with the thought of a time in hundreds of years when the dams on the Colorado will wash out and the canyons reform, has nonetheless never stopped ridiculing enemies with great old wisecracks ("He's so dumb he couldn't pour piss out of his boot if the directions were on the heel"). Each writer has given up more, I think, than he ever thought he could, but each is still looking, still writing.

For what is it reasonable still to dream?

In the short run—from the perspective of our lives—changes for the better in the man-altered landscape are likely to be small. Maybe, for example, we can reduce some of the noise we make. The sound of dirt bikes and all-terrain vehicles, for instance, is a frantic and monotonous snarl common to large areas of the semirural West, and could be reduced by legislation. At least economic resistance to such a change might be relatively slight, and the hardship the noise causes is more and more widely felt.

In the longer perspective of a hundred or two hundred years, assuming the country lasts, a variety of difficulties might be eased. This could happen through the engine of selfishness, as people realize that their welfare is threatened by others taking short views. When whole cities begin to die for want of water, for instance, taking with them both

profiteers and their idle fellow citizens, there will be a call for tighter restrictions on the use of whatever water is left. Pressure will similarly grow for land-use legislation (something that is now weak or nonexistent through the West, governed as most of it is by Republican legislatures), as landowners who are now unconcerned discover that the value of their holdings is being destroyed by sewage, chemicals, erosion, and the other consequences of excessive and anarchic development.

Eventually there will even be improvement in air pollution. After forests and lakes die, and a great many people suffer respiratory disease, the ongoing price—literally computed, no doubt—will begin to seem too high. Finally, an overwhelming majority of people will personally know victims of emphysema, lung cancer, and other pollution-related sicknesses, and will, in fear for themselves and their families, force a change.

It is hard to remember how the Southwest looked with the skies clear, but I like to imagine the time when it could appear that way again, not only for the cessation of suffering it would mean, but for the painters who would see it and bring it to us. How direct and unqualified their celebration could be, as it was for artists like John Sloan, John Marin, and Andrew Dasburg in New Mexico in the first half of this century, and later, Peter Hurd. For the new artists the experience could each day be as Kenneth Clark wrote: "Facts become art through love, and in landscape [painting], this all-embracing love is expressed by light." How blessed seem those pictures where the reference is easy, where it reminds us of an incontrovertible and unambiguous beauty that is there at any season or hour, out any door.

Our encounter with the land may also improve as people simply grow tired of their own and others' degraded behavior, weary enough to modify economic and behavioral rules.

Hunting is an example. At present, so-called wild animals are "managed," so that those of interest to hunters—who spend more money than bird watchers—are herded, artificially fed, medicated, and protected from predators. Whole ecological systems have thus been thrown off even further from whatever might remain of their original balance by alliances of game departments, hunters, and commercial interests that promote deer- and elk-hunting (now done with spotter planes, all-terrain vehicles, CB radios, and semiautomatic rifles). Any reduction in this industrial malformation and maltreatment of the surviving animal world would be an enormous gift. Just to be free of the sight of the "harvest," as it is nicely called, would improve autumn. Not to see, for example, as I did once, several men step out of a jeep, and, firing from the road, shoot the legs from a fawn before killing it.

It is possible to hope for even subtler changes. The nature of the buildings we live in, for example, may be altered as we learn respect for the environment. Economic justifications are now given for structures that defy the climate, disregard the original configuration of the geography, and in some cases require the wholesale destruction of adjoining regions for materials (as is presently happening, where I live in Colorado, with the mining of gravel for the manufacture of concrete to build cities). But at some point many of us, if given any chance at all, will gladly pay for a place of which it can be said, in Edward Thomas's words, "the house is kind / To the land that gave it peace."

And there are changes in geography that will cost nothing except honesty. Someday, for instance, we will go back to naming places as they are. It is probably too much to hope for the frankness that gave early Colorado place names like Lye and Oil Can, but it was those hard names that neutralized skepticism about the sweet ones like Maybell and Pleasant Plains, and this lesson in the value of candor may yet be

learned. At least there will come a time when we stop naming places for lake shores that aren't there, and attaching to names eastern suffixes like "glen" and "green." And if we call places by names that are accurate, we may ultimately find it easier to live in them. "The mind rests only on the stability of truth," Samuel Johnson said; rest and stability are aspects of home. Perhaps after we reach it, we may even learn again to compose songs based on names, treasured words made right by observation and history, songs like the ballad "The Rivers of Texas," listing the places where the singer courts his beloved—by the Pecos, Nueces, Wichita, Brazos, Nacogdoches, Sabine, Trinity, Guadalupe, Angelina. . . . "Give me your hand," he invites—"There's many a river that waters the land."

As much as I hope that future generations may enjoy these small and fragmentary changes, I must admit that the adjustments would not guarantee a respectful relation to the land. I take comfort, for that reason, in hope for a change not requiring large sums of money, and for the most part not in need of a majority vote—a reshaping that will come about, I think, as the result of the needs and efforts of individuals: a recognition and enrichment and preservation over the centuries of specifically sacred places. The final goal will remain that all places be recognized as holy, but, as a step on the way, locations of particular intensity will more and more be held dear.

Each of us already knows such places, exceptional in the peace and insight they bring. Until fairly recently, for instance, graveyards could be counted among them. It was understood that in living on earth as breathing compounds of dust we are part of what is eternal, and so marking the location of the dust in grave sites served as a reminder of that consolation. It also afforded others a place to celebrate,

with flowers or just attention and memory, the caring of previous lives.

I think of the grave of a man I knew on the plains. He was the editor of a small-town newspaper until, during the thirties, the town withered, leaving eventually just his shop and two houses in the middle of the prairie. He stayed on, operating a tiny post office that served a hundred square miles of farms and ranches. In 1978 he died and was buried in the town's cemetery, an acre by then not easily distinguishable at a distance from the rest of the grasslands. His gravestone reads "Clyde L. Stanley—Keota, my home for 63 years." However terse that is with the honesty of a last thing, it is compelling in its passion. He must have thought about the words for a long time to conclude so unequivocally what mattered most, remembering I suppose the blizzards he'd watched through the front windows, the smell of sage after summer rains, the conversations he'd had with generations of neighbors. . . . The place—that was who he was, by his love for it.

Sometimes one doesn't even have to visit a location to take heart from it. I once bought a vase that had been made from clay dug on Tillamook Head, a promontory on the northern Oregon coast, and fired there in a primitive kiln in the forest on the mountain's slope. Though I have several times walked the headland, I will never find, in its dense growth, the clearing where this beautiful object was made; though when I touch it, I can imagine the site of its origin. Nothing, not even the lashing storms of winter, nor the thought of the storms we ourselves bring, disrupts the quiet of the place I know is there, with its faint smoke drifting through conifers.

If there is anything lacking in such places, lovely though they are, it is a community of observers. By the paradoxical

mathematics of beauty, they are, like songs, more ours if we share them. But this is difficult in our time because relatively few people care, and because those who do are thinly dispersed. Calling such places to public notice can, as well, risk their destruction by vandals.

There are some activities now, though, that seem prophetic. A group of photographers is, for example, paying new attention to places that have been venerated by Native Americans. The reward to the photographers is not only the satisfaction of giving us truthful pictures, but the experience of being, with all their attention, there. Rick Dingus described in a letter an afternoon when, while working in the desert, he waited out a cloudburst "in a cave with Coyote painted on the ceiling. Bear, Turtle, Bird, Plumed Serpent and others were there too. Lightning crashed, the ground shook with thunder, water dripped into the catch basin carved near the Serpent. Then the storm passed, with the sun back out, and the wet earth drying, clean-smelling, regenerated." He has discovered that he can share some of these experiences with Indians: "We talked about my dreams and his, the stories connected to the place. All of this related not only to where we were but to where our time is—where it came from and where it is going."

The photographic work being done at these sites is also important, of course, because the places are unavailable to the majority of us. Even those locations to which we might make our way by long travel are now mostly being destroyed or, in order to save them, closed. They ought to be barred to us, I think, once we have learned from their example, both so that Native Americans can use them without distraction, and so we will be compelled to develop our own places of respect and harmony. Only insofar as we are forced by our need will we realize that there are things more appropriate to mountaintops than climbing registers, that there are trees

it is right to touch only as if they were human, and that there are prairie draws as true to the opening of the Twenty-third Psalm as any green valley in Judea.

I'm encouraged by artists brave enough to attempt the creation of sites similar to those developed for worship by earlier cultures. Though some of the "earth works" done in the 1970s were extensions of commercially inspired aestheticism common in painting and sculpture, others originated in sources far removed from the usual frivolity of marketable "art." I haven't visited them, but pictures suggest that Walter de Maria's *Lightning Field* and Nancy Holt's *Sun Tunnels* are creations of a serious order, as is James Turrell's current Roden Crater project. Each is located in a spot that is inherently awe-inspiring by virtue of the sweep it affords the eye—over a plain, across salt flats, and from within a volcanic cone, respectively—and by the silence of isolation. Each has been, or will be, brought to focus by the addition of humanly shaped objects that relate the spot to a wider context—to clouds, to the sun and the constellations, to the cosmos as a whole.

Someday not only will there be more places that encourage a harmony with nature, but there will be, I think, new sacred sites originating in the principal religious traditions of our culture, Judaism and Christianity, the correction of which seems to me imperative because their abandonment is impossible (one cannot walk away from the center of one's culture and survive; Judaism and Christianity embody insights that are unique and, at least in my experience, true). Years ago, when I found myself with time to spare in Cologne and Aachen in West Germany, I decided to visit several churches, recommended in a guidebook, that had been built by an architect of whom I had not heard, Rudolph Schwarz (I later discovered a startlingly heartfelt testimony to him by Mies van der Rohe). One church, located

in an otherwise drab suburb, was said in the guidebook to call to mind—as Schwarz had mysteriously permeated the structure with natural light that seemed to have no source—the Eastern Orthodox definition of a church: a building, analogous to the mother of Christ, containing the uncontainable. To my wonder, it proved to be so. This church, St. Christophoros in Cologne-Neil, was unlike any modern American religious building with which I was familiar. At the back of the chancel was the barest sketch, in otherwise blank concrete, of the risen Christ; to the side of the pews there was another, equally simple, of an angel, her face turned toward worshipers and her finger raised to her lips for silence.

My memory of Germany, which is otherwise of a mostly lost geography, is transformed through the recollection of my visits to a half dozen churches designed by this one man. Recalling them helped suggest to me, when I returned to America, that not just churches, but whole urban and suburban landscapes might be revealed as sacred if we brought to them a measure of the same passionate regard that Schwarz had brought to his specifically religious commissions. It was, in a way, why I started photographing, to see if I could find, by pictures, an emotional equivalent to the churches. The goal was in many ways naive, however, and over the years I have found myself looking for churches in America of the quality of Schwarz's in Germany. Working on Colfax in Denver or Pico in Los Angeles, I sometimes think that if they are here they are small, even anonymous on the outside, focusing inward, holding a stillness removed from, but redemptive of, the street.

On the Japanese island of Shikoku there is, as described by Oliver Statler in *Japanese Pilgrimage*, a footpath that follows the thousand or so miles of shoreline, linking shrines cele-

brating events that occurred during a walk there by the Buddhist saint Kobo Daishi (774-835 A.D.). Pilgrims say that they are accompanied by him as they travel; the route eventually leads back to the start and thus to a central aspect of his wisdom.

Part of the trail, according to Statler, now runs along freeways. Unpleasant as that may be, the walk next to cars and trucks apparently does not carry with it, however, the threats of violence—shouts, things thrown, Dobermans lunging against fences—that it would along highways such as those leading to the grasslands of northeastern Colorado.

These obstacles to peace exist, however, because of who we are, not what the land inherently is. Perhaps someday America will have trails like those found in Japan, or England, where public paths commonly cross private land, or Sweden, where any citizen at all can walk to within sight of any house. Pilgrimage routes in America come easily to mind—walks to clapboard churches on the high plains, to adobe chapels in the Sangre de Cristo mountains of New Mexico, to locations along the Rio Grande that have served as painters' motifs, to sites on the northwest coast that inspired the poetry of Theodore Roethke—though the paths for which I hope most are between places as yet unrecognized by us, to mountains celebrated by novelists who haven't yet written, and along streets in cities loved by filmmakers whose work we haven't yet seen. By that time travelers might enjoy a community of spirit with each other and with residents nearby who, strengthened through the privilege of living there, would trust visitors. Eventually—why not hope?—there might even be retreats, as on the route encircling Shikoku, where part of the welcome offered would be to share a community's practice of silence. Or its calendar, where a painting or sculpture might be brought out only once a year, or where things might be said

at appointed times as they had been said for hundreds of years.

The circular pilgrimage route in Japan leads to an emotional understanding that I want very much to come to know, especially as I am an American, the dangerously empowered legatee of Western, linear ideas of time and progress. I think of a circular walk I would like to make along the Platte River, west from the Missouri River to the Rockies, and then, by another pioneer trail like the Smoky Hill, back to the Missouri again; I would like to walk prairie grass with the setting sun at my back for a while, day after day. Not that at my age it would convince me to go east to live, but it might encourage me, wherever I must live, to think of that place as home.

Most of my hopes are for the amelioration of problems—a more conservative pattern of land use, a reduction in air pollution, a more prudent consumption of water, a lessening of animal abuse, a more respectful architecture. When I think about the possibility, however, of a landscape enriched by specific places to which we have responded imaginatively and with deference, I find myself thinking that we might be permitted to call it improved. Samuel Johnson wrote once of a place he visited called Hawkstone Park in which he found the geography so untamed that "the ideas which it forces upon the mind are the sublime, the dreadful, and the vast," compelling, in "the horrour of solitude, a kind of turbulent pleasure between fright and admiration"; for a visitor there, "his walk is an adventure and his departure an escape." Johnson contrasted Hawkstone with another estate, a garden set below mountains, a scene in which there was "grandeur tempered with softness." I remember sensing for the first time, the summer I was eighteen, the pull of those two kinds of geography. I was working for the

Forest Service in the San Juan Mountains of southwestern Colorado—on precipitous, timbered slopes, and often in storms. Late on Saturday afternoons we would leave that setting for a few hours in town. It was a long trip, down thousands of feet through warming air, eventually leading to a point from which we could see our two-block-long destination, situated in the center of an ideal ranching valley, gold in last light. The community promised a milk shake, a haircut, and a movie (always a western), all of them wonderful, but the overlook would hold us for a moment, even in our youthfulness, by its serenity.

Many times and places since then I have tried to photograph the quality in that scene, having slowly been brought to realize that however much I loved what I saw of the western American wilderness, to have loved it raw best, lifelong, would have required a misanthropy that I couldn't have borne. Like many, I have come to hope to find a valley, in sight of peaks but gentler than they are, and to be permitted to make the valley even more itself, better consonant with a harmony in nature that seems finally more true than nature's violence. To try to do this is, I know, in consideration of our history, to embark on another failure, but I believe that our weakness is at least understood, and that we may hope to be forgiven.

If most of the larger possibilities we have considered are beyond the span of our lives, for what is there to hope within their span? If as individuals we can improve the geography only slightly, if at all, perhaps the more appropriately scaled subject for reshaping is ourselves.

The evidence is cautionary. Those little reforms that I have managed in myself and that for the moment seem more or less in the right direction have been slow and late: For a half dozen years as a young man I was a hunter; for

many more years I enjoyed photographing cattle on the plains, diverted by what seemed their part in an attractive myth, never thinking of what they did to the land or of what we did to them; I also used to take pleasure at the sight of the graceful sprays from center-pivot irrigation systems, machines that were in fact mining irreplaceable aquifers. What, I wonder, am I not seeing now? If only I knew.

I do know, nonetheless, people who have grown, if not to sainthood, to become better than they were, and better than I am. Against the weakness of my own anger I see their achievement—an opposition to evil made steady by their provisional truce with the part of it they cannot change. It appears often to be a victory requiring a whole life. We recognize their success in an evenness of voice, a serenity of hand, a kindness in small things that require patience.

When I have hope that we may improve a little, each of us, it is often after some personal contact with the land. By gardening, for instance. Our backyard has a common mixture of vegetables and flowers—zinnias, cosmos, squash, tomatoes— but as the places we enjoyed in the mountains have been lost, the garden has become a substitute for some of them, particularly for the space of the mountains' quietness.

There is, too, the common satisfaction of walking, which can sometimes be as unalloyed as that of working in the backyard, but more often leads into the diversity of modern life. Among the best descriptions I know of the rewards of exploration on foot is a small journal entitled *Of Walking in Ice* by the filmmaker Werner Herzog. In it he records a hike he made in winter from Munich to Paris, as a kind of sacrament for the health of a friend. Along the way he notes the frightening oddities of our landscape ("low-flying airplanes overhead all day, one of them coming so close that I think I saw the pilot's face"), he observes the coldness

of our society's positivism ("How I long to see someone kneeling before the roadside crosses"), and he experiences a sense of isolation and confusion ("If I actually make it, no one will know what this journey means"). There are, however, moments of gain: "The mice rustled very lightly in the flattened grass. Only he who walks sees these mice." He had recorded a little earlier that a new compass "does not have my friendship yet," but, after studying the way the mice tunnels lie exposed between grass and snow, he realizes that "friendship is possible with mice." It is an observation worthy of Kafka, as befits our age, but more significantly, worthy of St. Francis as well. It is synoptic of what we can enjoy by walking—a kind of friendship with things, made possible by a pace that allows regard for the least conspicuous miracles.

Art, too, is a source of pleasure to be taken in the landscape. Making art—being able to say what one sees that is whole—is an enormous relief, as if one had been held dumb by an impediment of speech, and then abruptly cured, enabling one to say, and thus understand better, what it is that is most important.

Studying the art of others helps too. When we discover, in a landscape toward which habit has made us uncaring, a Hopper sky or Cézanne rocks, the terrain is suddenly compounded into something fresh and larger. Even minor art—songs, for instance—can reawaken our affection for places, and our belief in the certainties they offer. I cherish a ballad—half funny, half sad—describing a man who gets a letter from the East asking why he works on a ranch for low pay, speculating he "must have gone crazy out there"; the man answers to himself in the refrain, "You've never seen spring hit the Great Divide." It reminds me of my season there, and, in the loveliness of the song, the place and I both seem—I don't know how—safe.

Finally, centrally, there is the joy to be found in a landscape experienced with family and friends. There are days that become, in the urgent and hushed sharing of a wonderful place with someone else, as much as I expect to know of the world for which I dream. To hear one's name, and the invitation, spoken with the assurance you will together see the same gift—"Look."

I write this on a year of retreat in a small Oregon town next to the Columbia River where it enters the Pacific. Because of the river's size—it is three and a half miles wide—and the ocean, and the town's location on a hill, it is a place of extraordinary beauty, though even it has ghosts. From my desk at an attic window I can see the riverfront that used to be, when we first came here twenty-five years ago, lined with working docks and canneries, but where now there are mostly rotting pilings and empty buildings, the salmon having been decimated by overfishing and by the destruction of their habitat. On the main street, where trucks used to pass carrying a single enormous log, they now carry twenty-five or thirty spindly ones to be chipped for composition board, the whole Coast Range having been cut bare of first growth.

For a century, Scandinavians came here as fishermen, loggers, housewives, and cannery workers, and this morning on the radio there is Finnish music, call-in requests from old people; many in the town are not, even after a lifetime, wholly assimilated. They are loyal to their adopted country, but have held something back, something perhaps beyond their power to give.

It occurs to me that I wasn't entirely accurate to claim that our disinheritance now is especially severe or out of character with our past. Many who came west did not, after all, want to stay once they saw it. Or like the immigrants to

this town, they learned that their coming had imposed on them an injury. How else explain the carefully tended birch trees where alders are native?

America was not settled only by those following a dream of profit. Just as often, our forebears' motive was to escape some nightmare of hunger or stultification or violence, and they would always love, with a sudden intensity against which they could never fully guard themselves, the geography where they were raised—the flowers, trees, birds, clouds, and lay of the land. Ours has never been, really, just a country of easygoing transients. There has always been a counter-tradition of learning to make the best of exile, of building from recollections of what was prized and torn away.

TWO LANDSCAPES

AT OUR BEST and most fortunate we make pictures because of what stands in front of the camera, to honor what is greater and more interesting than we are. We never accomplish this perfectly, though in return we are given something perfect— a sense of inclusion. Our subject thus redefines us, and is part of the biography by which we want to be known.

One of the locations where I have tried to photograph is a plateau northwest of Denver, between the city and the mountains. I first saw it when I was fourteen, when our family moved out from Wisconsin—it was just visible from our new house—and my father and I soon went to explore parts of it, walking there in late summer among stalks of white yucca blossoms. In October we climbed foothills in order to look back over the plateau toward our home and the city beyond. The view was like nothing we had known— windswept, sun-bleached, vast.

Eventually I went away to school in California, but when

First given as a talk at the Philadelphia Museum of Art in 1989, this essay was later published, in slightly different form from that presented here, in *The Ohio Review*, Fall 1992.

I came back I walked the edges of the tableland again, this time with a camera. Arapaho Indians had, I learned from reading, once built rock blinds on top of a hogback at the plateau's southern boundary, a location from which they enjoyed a commanding view of the grasslands eastward. I took many photographs of and from the ridge, among them one that served as the cover for a book.

The plateau has changed over the years: It is now often under smog, the foothills next to it have been built with houses, the hogback with the Indian overlook has been mined for clay and is being partially recontoured as a land-fill, and an expressway is scheduled to cross part of the area.

Worst, in relative secrecy there was constructed at the center of this geography an atomic-weapons factory. The Rocky Flats Nuclear Weapons Plant is a collection of low buildings, unimposing to the eye, inside of which the United States shaped plutonium for nuclear detonators. In the process it exposed those living in Denver to plutonium suspended as smoke. It also poisoned groundwater, and so seriously contaminated the soil that the envisioned highway may have to be rerouted for fear of the dust that construction would raise.

The plateau has been a focus of my work for twenty years both because it was near my home and because the location was and is characteristic of the American West in general, and even of the world. Though not many landscapes are at once as beautiful and as damaged as is this one, most are, as we have invaded them, similarly discordant. A typical vacant lot today is likely to have in it not only scattered vegetation but broken asphalt, Styrofoam, and abandoned appliances; the air may at times smell of wild-flowers or rain, but as likely also of oil or sewage; there may be audible the call of a dove, but often against some steril-ity like the flapping of a plastic bag caught on barbed wire.

If the state of our geography appears to be newly chaotic because of our heedlessness, the problem that this presents to the spirit is, it seems to me, an old one that art has long addressed. As defined by hundreds of years of practice—I think this history is vitally important—art is a discovery of harmony, a vision of disparities reconciled, of shape beneath confusion. Art does not deny that evil is real, but it places evil in a context that implies an affirmation; the structure of the picture, which is a metaphor for the structure of the Creation, suggests that evil is not final.

John Sloan spoke clearly about these matters: An artist, he said, "seeks to find order in life, and to invent ways to put that sense of order in his work as a document of his understanding." An artist, in other words, "invents" from the confusion of life a simplification, a picture with more order than the literal subject apparently has, so as to suggest by analogy a wider coherence throughout life. The artist intuits this "understanding" of life. Art is not science, and isn't content mechanically to record just what is objectively verifiable. Art does not in fact prove anything. What it does do is record one of those brief times, such as we each have and then each forget, when we are allowed to understand that the Creation is whole.

The word *home* is rich with meanings, but a definition that comes close to encompassing them all is one by the poet Lorine Neidecker: "Home," she wrote in a poem of that name, is where "no fact is isolate." In those circumstances, she said, there is peace. Art has, I think, fundamentally always been about that place and condition.

Another scene that has kept me photographing is, unlike the plateau, an ideal one. And, since I am a person of my time, its perfection used to worry me. Was I being sentimental to record it? Was I bringing more emotion to this faultless place than it deserved, since it is not where most of us live or can choose to live? Over the years I have begun to

believe, however, that we live in several landscapes at once, among them the landscape of hope, and that though we must usually focus on what is characteristic of the immediate and troubled present, it is rash to say that other geographies are unimportant or even finally separate.

This second place is a simple, generic one—a country crossroads on the high plains. There are thousands from which to choose. Often there doesn't seem to be anything there at all—just two roads, four fields, and sky. I feel foolish to have stopped, but small things can become important—a lark or a mailbox or sunflowers. And if I wait I may see the architecture—the roads, the fields, the sky.

Were you and I to drive the plains together, and the day turned out to be a good one, we might not say much. We might get out of the truck at a crossroads, stretch, walk a little ways, and then walk back. Maybe the lark would sing. Maybe we would stand for a while, all views to the horizon, all roads interesting. We might find there a balance of form and openness, even of community and freedom. It would be the world as we had hoped, and we would recognize it together.

.

ACKNOWLEDGMENTS

The author and Aperture Foundation, Inc. are grateful to those who have provided illustrations for Why People Photograph: Whitney Museum of American Art, Josephine N. Hopper Bequest (I); Collection of the author, © Nicholas Nixon, Zabriskie Gallery, New York (II); © Association des Amis de Jacques-Henri Lartique (III); Peter Hunter (IV); Dorothea Lange Collection, The Oakland Museum, Gift of Paul S. Taylor (V); George Eastman House (VI); Robert Miller Gallery, New York, and Fraenkel Gallery, San Francisco, © Lee Friedlander (VII); Collection of Joyce R. Strauss (VIII); Charles Bregler's Thomas Eakins Collection at the Pennsylvania Academy of the Fine Arts, Philadelphia—purchased with the partial support of the Pew Memorial Trust (IX); Magnum Photos, Inc., © Henri Cartier-Bresson (X); Hirshhorn Museum and Sculpture Garden, Smithsonian Institution—transferred from the Hirshhorn Museum and Sculpture Garden Archives, 1983 (XI); All rights reserved, The Metropolitan Museum of Art (XII and XIV); © 1981 Center for Creative Photography, Arizona Board of Regents (XV, XVI, and XVII); The Paul Strand Archive, © 1950, Aperture Foundation, Inc. (XVIII, XIX, XX, and XXI); Laura Gilpin Collection, © Amon Carter Museum

(XXII and XXIII); Collection of the author, © Judith Joy Ross (XXIV); Magnum Photos, Inc., © Susan Meiselas (XXV); Collection of the author, © Michael Schmidt (XXVI); Albumen-silver print, 7 x 9 $^3/_8$ in., Abbott-Levy Collection, The Museum of Modern Art, New York—partial gift of Shirley C. Burden (XXVII); George Eastman House (XXVIII); The J. Paul Getty Museum, Malibu, California (XXIX).

Grateful acknowledgment is made to the following poets and their publishers for permission to reprint material under copyright: Kim R. Stafford and the estate of William Stafford for portions of "Rich Man" from *Braided Apart* © 1976, published by Confluence Press, Lewiston, ID, and "Prairie Town" from *Stories That Could Be True* © 1977, published by Harper & Row, New York (pages 51, 136); and A. R. Ammons for a portion of *Sphere* © 1974, published by W. W. Norton & Company, Inc (page 43).

A *limited edition of twenty-five original gelatin-silver prints and five artist's proofs of* Cottonwood Leaves, Boulder County, Colorado, 1988 (*cover image*), *signed and numbered by Robert Adams and accompanied by a signed edition of* Why People Photograph, *is available through Aperture.*